THE MIDLAND & GREAT NORTHERN JOINT RAILWAY
THROUGH TIME
Steph Gillett

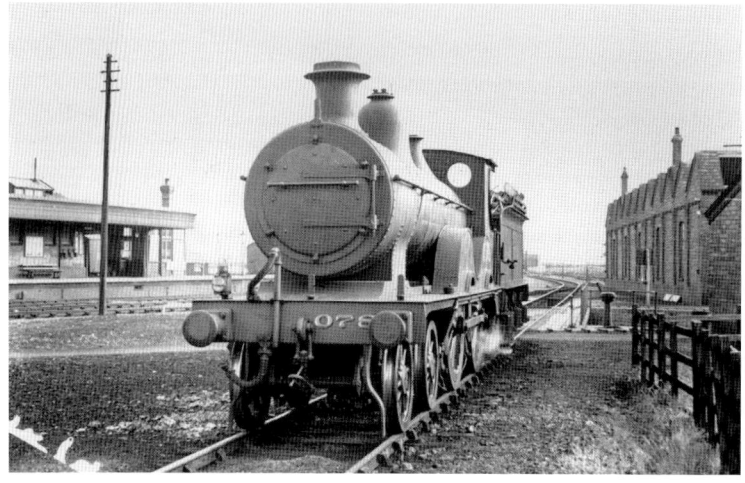

Ex-M&GNJR C Class 4-4-0 No. 078 (built by Beyer Peacock in 1899) stands at Bourne locomotive depot in May 1937. (H. C. Casserley, courtesy of Margaret Casserley)

For Laura.

Front cover top: M&GNJR C Class 4-4-0 No. 3 passing South Lynn Junction signalbox with the 4.45 Peterborough to Yarmouth train on 24 June 1929. (H. C. Casserley, courtesy of Margaret Casserley)

Front cover bottom: BR-built Ivatt 4MT Class 2-6-0 No. 43142 near Caister-on-Sea with the 3.00 Yarmouth Beach to Leicester service in August 1957. (E. Alger/Colour-Rail.com)

Back cover top: M&GNJR 'A Tank' Class 4-4-2T No. 41 at Yarmouth Beach on 26 June 1929. (H. C. Casserley, courtesy of Margaret Casserley)

Back cover bottom: Sheringham East signalbox, moved to the Up platform at Sheringham in the early 1970s to make way for road improvements, was returned to near its original position by the reinstated level crossing in 2012. (Author)

First published 2019

Amberley Publishing
The Hill, Stroud, Gloucestershire, GL5 4EP
www.amberley-books.com

Copyright © Steph Gillett, 2019

The right of Steph Gillett to be identified as the Author of this work has been asserted in accordance with the Copyrights, Designs and Patents Act 1988.

ISBN 978 1 4456 7248 9 (print)
ISBN 978 1 4456 7249 6 (ebook)

All rights reserved. No part of this book may be reprinted or reproduced or utilised in any form or by any electronic, mechanical or other means, now known or hereafter invented, including photocopying and recording, or in any information storage or retrieval system, without the permission in writing from the Publishers.

British Library Cataloguing in Publication Data.
A catalogue record for this book is available from the British Library.

Origination by Amberley Publishing.
Printed in Great Britain.

Foreword

While I have been writing this book, those who remember the Midland & Great Northern Joint Railway (M&GNJR) will have been marking the sixtieth anniversary of its closure in February 1959. They will have been joined by many others who did not know the M&GNJR but have become enthusiasts of this much-missed line, the longest 'joint' railway in Britain. I count myself among the latter group, only becoming aware of the railway through the preserved section from Sheringham towards Holt when living in Norfolk for a few years in the mid-1980s. I will also have unknowingly walked along a section of the trackbed from Norwich City with, at the time, very little awareness of the railway.

In the following pages I have tried to provide a short history of the railway, from amalgamations of supposedly independent concerns through its more prosperous periods, decline and inevitable closure under British Railways (long before the Beeching Report had been conceived), and the subsequent revival of at least some of the parts. This follows a generally chronological approach with some jumping forwards (or backwards) in time to avoid a too disjointed story. It is a history, though, that requires some knowledge of the area or reference to a map but I hope I have done it justice in the space available.

The images, historic and contemporary, show the line both in operation and post-closure, and surviving evidence that can still be seen. I have endeavoured to arrange these in a way that makes sense in both date and geography. I hope that readers will, if they are not already, become enthusiasts of the M&GNJR and consider supporting one or more of the organisations that exist to preserve its memory.

<div style="text-align:right">
Steph Gillett

Bristol

June 2019
</div>

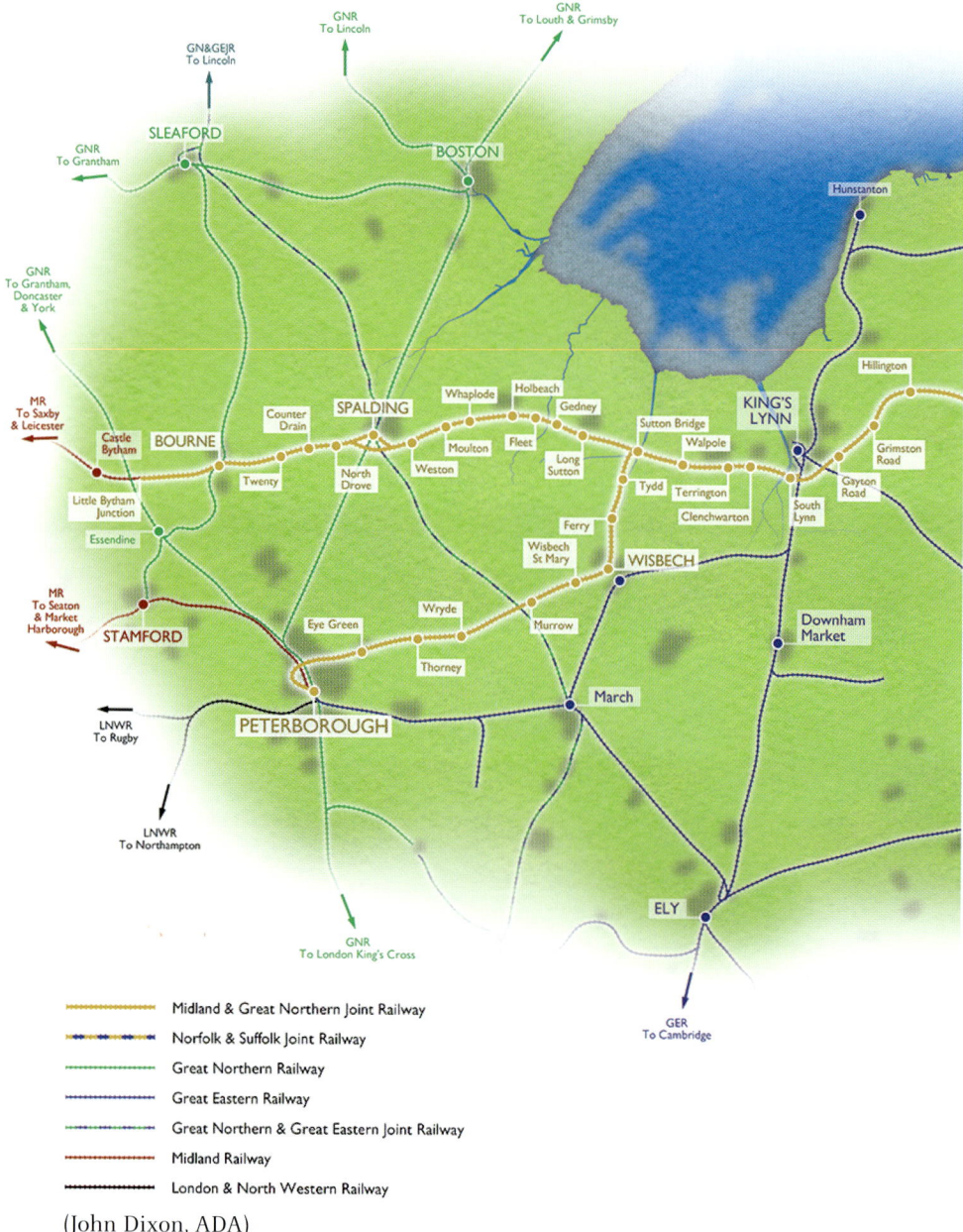

(John Dixon, ADA)

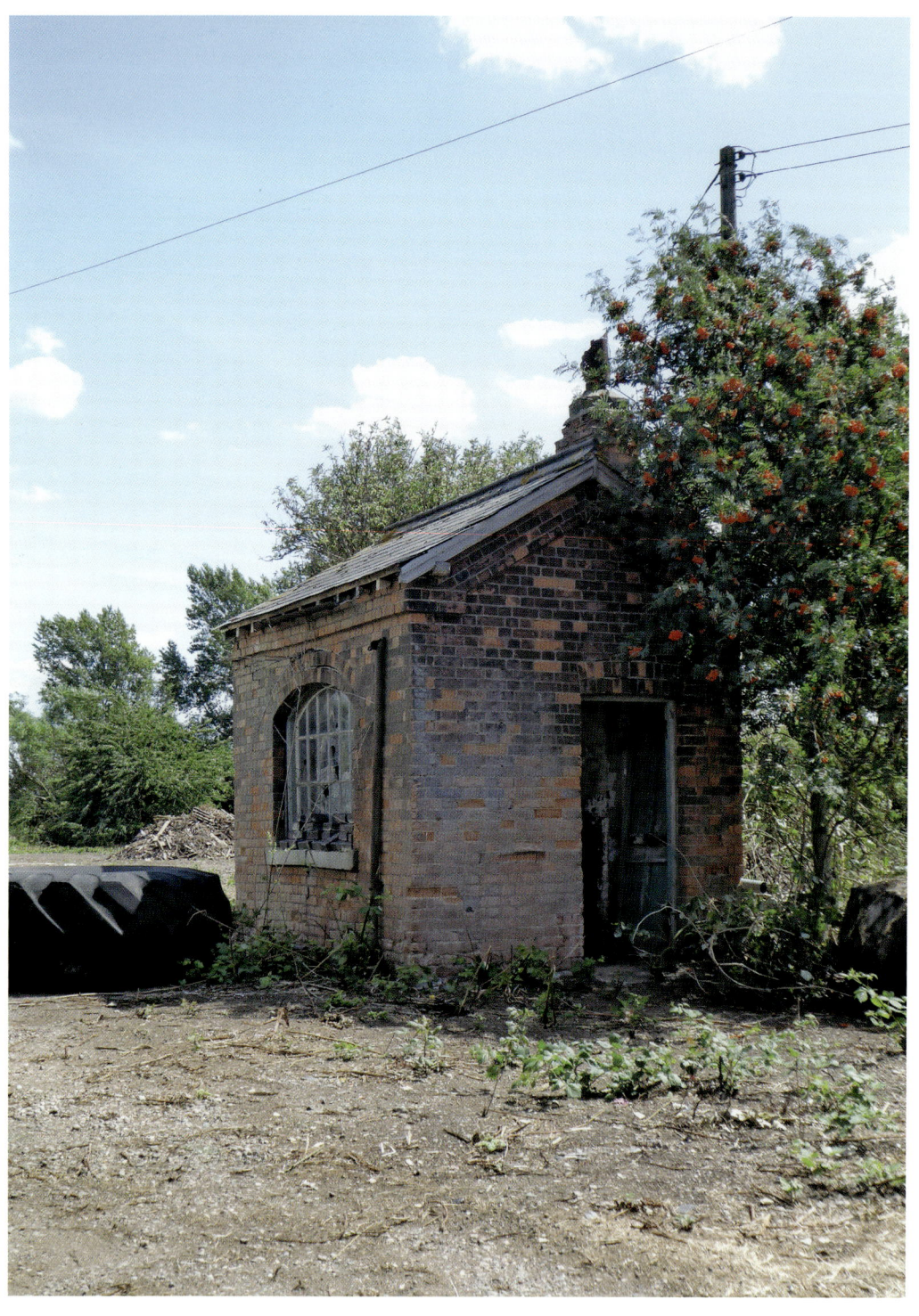

Evidence of the M&GNJR can be found throughout the former system, such as this weighbridge office at Wryde. (Amber-Ruth Watson)

The M&GNJR

Origins

The origins of the Midland & Great Northern Junction Railway (M&GNJR) were laid down by several small companies that were built to provide rail links to isolated parts of Norfolk. In its final form the M&GNJR provided the Midland Railway (MR) and the Great Northern Railway (GNR) with direct access to the region, in which the Great Eastern Railway (GER) otherwise had a monopoly. The network ultimately had lines from Peterborough and Little Bytham (Lincolnshire) in the west through Spalding and Lynn eastward to Melton Constable and on to Norwich, Cromer, Yarmouth and, with the GER, to Lowestoft and Mundesley.

The Eastern Counties Railway (ECR) was set to provide the first rail link to Norfolk; when incorporated in July 1836 it was planned to run from London to Norwich and Great Yarmouth via Ipswich. Originally built to a track gauge of 5 ft (1.5 m), the ECR opened to Colchester in March 1843 but the much-criticised company abandoned the route beyond due to as lack of capital. Several other proposals during the 1840s to variously link parts of north and west Norfolk with Norwich and elsewhere all failed.

The first railway in the county was the Yarmouth & Norwich Railway (Y&NR), incorporated in June 1842, which was a response to the ECR's failure and involved both George and Robert Stephenson. The 20.5-mile line ran via Reedham and opened in May 1844. The Y&NR amalgamated with the Norwich & Brandon Railway in June 1845 to form the Norfolk Railway, which was in turn taken over by the ECR in May 1848 (and was later part of the M&GNJR's great competitor the GER).

However, the first line that eventually became part of the M&GNJR was that of the Norwich & Spalding Railway (N&SR), authorised in August 1853 (as the Spalding & Holbeach Railway), with plans to ultimately reach Norwich via running rights over other railways. This line opened the 7.5 miles from Spalding to Holbeach in November 1858 and, when it had secured further capital, a further 8 miles on to Sutton Bridge in July 1862. By agreement the GNR worked the N&SR for half of the gross receipts.

Meanwhile, a number of other railways had penetrated the region from the south and west, connecting with most of the significant towns later also served by the M&GNJR, lines that ultimately became part of the GER along with the ECR in August 1862. The north-east of Norfolk, though, was not served until the East Norfolk Railway opened to North Walsham in October 1874.

The Lynn & Sutton Bridge Railway (L&SBR) was authorised in August 1861 and, when opened in March 1866, extended the N&SR route east by 9.5 miles. The L&SBR was required to provide a bridge over the River Nene at Sutton Bridge but, by further Act of July 1863, this was avoided by sharing the existing road bridge. Passenger services on this line were also operated by the GNR (goods services began in November 1864). In the opposite direction the Spalding & Bourn (later Bourne) Railway (S&BR), formed in July 1862 and opened in August 1866, extended the line by another 9.5 miles west to an end-on

junction with the Bourne & Essendine Railway (also worked by the GNR), which provided a link to the GNR network at Essendine.

The Peterborough, Wisbech & Sutton Bridge Railway (PW&SBR), authorised in July 1863, opened to passengers in August 1866 (two months after the goods service). The 26.5-mile line connected with the MR Peterborough to Leicester line just north of that line's junction with the GNR. The line was worked by the MR for half the profits. The N&SR had twice been refused powers to extend its line to Wisbech but was granted running powers to this location via the PW&SBR.

In July 1866 the L&SBR and S&BR companies amalgamated, by Act of Parliament, as the Midland & Eastern Railway (M&ER) and leased the N&SR (which remained nominally independent) to secure running powers to Peterborough. A proposed extension to the MR at Saxby was dropped from the Bill due to opposition by the GNR. The GNR, however, permitted the MR to run over its line from Bourne to Essendine and on to Stamford (and a new junction there with the MR). A further Act in August 1867 brought the M&ER under the joint management of the MR and GNR for an annual rent of £15,000 with half the surplus profits paid to the original companies. The line became known as the Bourne & Lynn Joint, with its own staff and uniform with Mr R. Dykes appointed manager. Robert Arthur Read (1830–1908), who was to have important roles with both the M&GNJR and the Somerset & Dorset Joint Railway (S&DJR), became a director of the N&SR in 1875 and of the M&ER in 1877.

Lynn & Fakenham Railway

To the east, the Lynn & Fakenham Railway (L&FR) was established in July 1876, despite opposition from the GER. The line opened to Massingham (11.75 miles) from a junction with the GER's branch to Hunstanton in August 1879, and on to Fakenham (a further 8.75 miles) the following August; trains were at first operated by the railway's contractors, Wilkinson & Jarvis. J. W. Mann (d. 1894), previously with the North Eastern Railway, was appointed as locomotive superintendent for the L&FR in 1880. He established locomotive and engineering workshops at Melton Constable in 1881 that were to become substantial over time; the original facilities at Fakenham were then used for goods sheds.

Further east, the Great Yarmouth & Stalham Light Railway was incorporated in July 1876 and construction started the following January. The 17.75-mile line from Yarmouth to Stalham was completed in stages between May 1877 and July 1880. A further Act in May 1878 authorised an extension of 6.75 miles to North Walsham (opened June 1881) and a change of name to the Yarmouth & North Norfolk Railway (Y&NNR). Operated as a light railway, the GER was deterred from a takeover bid or seeking running powers, as it would have cost too much to make it usable for the competitor's heavier trains.

The Yarmouth Union Railway (YUR) was authorised in August 1880 to construct a short tramway to connect the Y&NNR with the GER's dockside lines. Construction was eventually undertaken by the Y&NNR and opened in May 1882. The work was supervised by William Marriott (1857–1943), recently moved from the GNR to contractors Wilkinson & Jarvis, and who later made significant contributions to the M&GNJR.

Also in August 1880, an extensive Act empowered the L&FR to construct several important lines, including a 9.25-mile extension from Fakenham to Melton Constable via Thursford (which opened in January 1882) and from here on to Norwich via Whitwell and Drayton (a total of 22 miles). A line from Melton Constable to Blakeney was to have gone via Holt and Kelling, with a branch from this to Sheringham.

In August 1881 an Act for connecting the L&FR and Y&NNR lines via Melton Constable and Aylsham was passed. This was to provide a rail link all the way from the GNR main line in the west to Yarmouth, breaking the GER's monopoly in the region (which latter company naturally opposed the Bill). The 1881 Act also gave the L&FR approval for a branch from Kelling on the proposed Melton Constable to Blakeney line (authorised a year earlier) to Cromer via Sheringham and West Runton.

The L&FR extension south from Melton Constable had reached Lenwade (10.75 miles) by July 1882 and the final section on to Norwich (a further 10.5 miles) opened in December 1882 with a special train from King's Cross, London, carrying guests for a celebratory banquet at St Andrew's Hall. Completion of the line finally achieved the N&SR's aspirations of 1853, though the station at Norwich City was not fully finished until 1883. The L&FR line reached the highest point of 312 feet (95.1 metres) above sea level on the M&GNJR system at Pigg's Grove near Thursford.

Eastern & Midlands Railway

A Bill for the amalgamation of the L&FR, Y&NNR and YUR was approved in August 1882 to form the Eastern & Midlands Railway (E&MR) from January 1883, which by the same Act absorbed the PW&SBR and M&ER in July 1883.

The E&MR's Melton Constable to North Walsham 17-mile link opened during April 1883; at the same time the station at Yarmouth was renamed Yarmouth Beach. Marriott was resident engineer for the construction works; the following year he was appointed locomotive superintendent, taking the place of Mann. Meanwhile, Read was establishing himself within the company, taking over as chair of the shareholders' meetings in October 1884 and shortly afterwards taking the title of managing director (confirmed in 1887), which allowed him to promote his plans for expansion, some of which resulted in lost deposits for unsuccessful Bills.

Construction of a 4.5-mile loop line to allow trains to bypass Lynn was authorised by an L&FR Act of August 1882. This Bawsey loop opened for goods traffic in November 1885 and passenger trains from January 1886. The line avoided the need for reversal at Lynn and payment of tolls, and risk of delays at the hands of the GER, for use of their station. A new passenger station was opened at South Lynn, near the existing goods depot, from where a shuttle service provided connections to Lynn (King's Lynn from 1888).

In December 1886 the E&MR decided not to build the approved line from Kelling to Blakeney and abandon its interest in the harbour despite losing the investment already made; this action was finally approved by Parliament in June 1888. Local residents appealed twice during the late 1890s for a connection to Blakeney but these overtures were rejected by both the M&GNJR and GER and the port never got its railway.

The E&MR line from Melton Constable towards Cromer was completed as far as Holt (5 miles) in October 1884. The 10-mile line beyond Holt to Cromer was completed in May 1887 by Marriott using direct labour rather than contractors and was opened the following month. An express service from King's Cross to Cromer first ran, in the summer only, from August 1887 using the Lynn avoiding line. The line to Cromer contributed to a 30 per cent increase of passenger numbers by the end of the year.

Robert Read had dealings with the MR through his other railway interests and favoured that company over the GNR for construction of a line west from Bourne and to take over running of the western section of the railway. However, after negotiations between the MR and GNR during 1888–89 it was agreed that a joint MR and GNR line would run from Bourne to the MR at Saxby, with provision for a junction at Little Bytham with the GNR. A joint committee of the MR and GNR met for the first time in March 1889 and, after this, controlled the western section of the E&MR. An Act in June 1889 confirmed the MR and GNR as joint operators of the line from Bourne to Lynn, as well as of the PW&SBR.

The expansion plans of Read were more than the company could bear and by 1889 the E&MR was in financial difficulties. A claim by W. Jones, a supplier of passenger carriages, for unpaid hire fees led to bankruptcy and Read was appointed official receiver in June 1889 in accordance with an Act of 1867. By the end of the year the company had debts of more than £180,000 (equivalent to around £183 million today). Disgruntled shareholders accused Read and his directors of mismanaging the railway and hiring rolling stock beyond available means, but their attempts in July 1890 failed to remove Read from his role as receiver. To save money, construction of a 5.25-mile branch line from North Walsham to Mundesley (not long since approved in June 1888) and the replacement of iron rails on the Y&NNR were postponed, though new passing places on the single tracks at Holbeach and Terrington were completed in May 1891.

Despite its financial problems the E&MR had been providing a good passenger and freight service and the MR was showing interest in establishing through goods trains. The express passenger service between King's Cross and Cromer began running all year from 1891. During the late 1880s and early 1890s Norfolk became increasingly popular for holidays. Large hotels opened in Cromer and the area became known as 'Poppyland'. Competition with the GER to capture traffic from London to here and the Norfolk Broads was intense. The GNR was also taking advantage of its route from the south to Lynn and Norwich via the PW&SBR. There was significant fruit-growing around Wisbech and special trains were sent to the Midlands, the north of England, and Scotland.

Midland & Great Northern Joint Railway

Already operating the western section of the E&MR, the MR and GNR expressed interest in the autumn of 1891 in taking on the rest of the system. The MR began running the eastern section on its own from November 1891 until terms had been agreed with the GNR in June 1892. A Bill for the two companies to take over the E&MR was also prepared with support of the shareholders and directors, which was passed by Parliament the following June 1893, despite some objections by the GER. This incorporated the Midland & Great

Northern Joint Railway (M&GNJR) as a separate company, and the E&MR was absorbed by it the following month. The M&GNJR was obliged, as part of the Act, to construct the Mundesley branch, though the time allowed for doing so was extended by Parliament the following year.

A 1.25-mile direct line, avoiding Spalding, was opened to goods traffic in June 1893, coinciding with the opening of the MR's 5-mile Bourne to Little Bytham line, also to freight trains. Authorised in July 1890, the new loop avoided the reversal of east–west trains at Spalding. The works included doubling of some single-track sections and a new platform at Spalding. Further doubling of track east of Spalding was completed in April 1896. Passenger trains did not use the avoiding line until May 1894, when the MR's Bourne to Saxby line was fully open. The 13 miles from Little Bytham signalbox to Saxby included the 330-yard (302 metre) Toft (or Bourne) tunnel, the only one on the M&GNJR.

The take-over by the MR and GNR allowed the M&GNJR to make improvements and investments to the infrastructure of the railway. Sections of single track between Peterborough and Sutton Bridge were doubled in stages from 1891 to 1892 and in 1892 the MR agreed to doubling the 3.5 miles from Bourne to Twenty. Further doubling of sections of the Peterborough to Yarmouth route took place at the end of the nineteenth century and the beginning of the twentieth. The Tyer's tablet system was introduced for all remaining single sections in 1893, alongside other track and signalling improvements.

The GNR was responsible for permanent way and signalling while the MR supervised the motive power department (the M&GNJR committee owned rolling stock and ran the trains). The MR chief mechanical engineer, Samuel Waite Johnson (1831–1912), introduced inside cylinder 4-4-0 and 0-6-0 locomotives to the M&GNJR, in 1894 and 1896 respectively, similar to those he designed for the parent company. This allowed withdrawal of some of the existing engines, which were having difficulty coping with growing passenger and goods traffic. Marriott was appointed as engineer for the M&GNJR, and also acted as locomotive superintendent, but had to relinquish his private contracts.

For some years plans for docks at Sutton Bridge remained alive, powers being renewed in 1895 but eventually abandoned; however a harbour branch line remained in use, serving a timber quay. A new rail and road bridge, authorised in 1892, across the River Nene at Sutton Bridge was opened in July 1897. The 176 ft (54 m) swing section of the bridge, which allowed shipping to pass, was originally hydraulically powered.

Norfolk & Suffolk Joint Railway

Despite their rivalry the M&GNJR and GER agreed in March 1897 to jointly promote a new railway from Lowestoft to Yarmouth via Gorleston (after first depositing competing Bills in 1896) as the Norfolk & Suffolk Joint Railway (N&SJR), with supporting Acts passed in June and August 1897. The N&SJR was constituted in July 1898, with its own staff and company seal but not trains, and led to the unusual situation of one of the partners being another joint railway (i.e. M&GNJR and GER). The N&SJR was authorised to run the Mundesley branch (opened from North Walsham in July 1898), build the 11-mile Yarmouth to Lowestoft link and construct an extension of 6.5 miles from Mundesley to Roughton

Road Junction for Cromer. An approved branch line 5 miles to the coast at Happisburgh was abandoned in 1902.

In July 1898, Marriott was recommended to succeed W. Cunning (who, previously with the Portpatrick & Wigtownshire Joint Railway, had been appointed in January 1895) as M&GNJR traffic manager. However, John J. Petrie (1856–1918), who had since July 1895 been serving with the MR on the Severn & Wye and Severn Bridge Joint Railway, was appointed and Marriott remained in his roles of engineer and locomotive superintendent.

Through expresses from the MR, which began running summer only in 1894, ran daily from 1898 and by 1900 there were two trains each way between Yarmouth and Birmingham and Leicester, usually with through coaches serving Norwich and Cromer. These trains became known as the 'Leicesters', although they later provided direct links as far as Gloucester and the West Riding.

Requests for a station at Weybourne had been rejected in 1897 but, following the opening of the Weybourne Springs Hotel in 1900 (demolished 1940), a new station was opened in July 1901. Workings near Holt and Kelling provided supplies of stone for ballast and other purposes. Goods traffic from elsewhere on the system at this time included potatoes from the Spalding area, sent via the GNR to London and other destinations north and south, as well as flowers. Freight from Norwich included mustard, machinery, footwear, beer, vinegar, seeds and cattle; that from Peterborough included bricks while fruit was sent from north Norfolk. Yarmouth was an important fishing port and young women from Scotland came via special trains during September and October to work, bloatering and kippering the herring catch. Fish trains ran to Peterborough for forwarding to Scotland, Lancashire, Yorkshire, the Midlands and London.

The 8.75-mile N&SJR line between North Gorleston Junction (for Yarmouth) and Coke Ovens Junction (Lowestoft) opened in July 1903; completion had been delayed by problems with earthworks south of the new Breydon Viaduct over the estuary of the Yare and Waveney rivers. Designed by Marriott, the viaduct was a significant civil engineering structure on the M&GNJR system, its 800 feet (243 m) comprised four fixed sections and a double swing span on the central pier. The new line to Lowestoft gave the M&GNJR access to a second important fishing port.

In July 1903 a new GNR service began running from Leeds to Spalding and Melton Constable, with through carriages for Cromer, Yarmouth and Lowestoft, and reverse. The MR 'Leicesters' had included Derby and Nottingham carriages from the summer of 1902, which became all year round from the autumn of that year.

The programmes of track doubling still left long sections of single line, causing delays to trains, especially during the busy summer holiday periods. To help speed up services the Whitaker single-line automatic tablet exchanger developed on the S&DJR was introduced in May 1902. The equipment was manufactured under licence at Melton Constable and all passenger lines except the N&SJR Mundesley branch were equipped. The apparatus was fitted to all M&GNJR locomotives (apart from a few shunting engines) and some GER tank locomotives for working through to Sheringham.

An Act of 1903 authorised a connection from the GER's North Walsham to Cromer line towards the N&SJR at Roughton Road, which became known as the Cromer Loop. The contract for construction was let in November and work began early in 1904. This N&SJR line was completed in two sections with the M&GNJR, N&SJR and GER triangle at Roughton Road, Newstead Lane and West Runton ready in July 1906, and the Cromer (Roughton Road) to Mundesley coastal line open for passengers in August 1906 (and for goods the following March) after delays due to a contractor going bankrupt. The M&GNJR began running into the GER's Lowestoft Central station from 1907 in return for the GER using the line to Sheringham for up to eight passenger trains daily. Despite all these developments there was a fall in receipts after 1907. Savings in expenditure had to be made and fares from King's Cross were reduced in an attempt at promoting the 'Poppyland' and 'Broadland' destinations.

The workshops at Melton Constable began constructing permanent way components from concrete, an innovation introduced by Marriott, including fence posts from 1909. Concrete sleepers were introduced from 1916, and signal posts especially during 1916 and 1917, some of which were supplied to other railways.

The First World War in 1914 brought to the M&GNJR the same burdens carried by other railways: the loss of staff to the armed forces, extra trains carrying troops and military stores, and the works at Melton Constable were put to making aircraft components and work for other railway companies. The dangers to North Sea trawlers and their use as minesweepers caused a decline in fish traffic but freight was diverted from coastal shipping to the railway. To meet the war effort there was an increase in goods carrying foodstuffs produced locally. Passenger services were generally reduced and slowed during the war.

As with the rest of Britain's railway network, the M&GNJR was very run-down at the end of the war in November 1918 and normal services took a long time to be re-established. Fruit and fish traffic, however, both returned after 1918. The government retained control of the railways, which it had assumed at the start of the conflict, until 1921. Although holiday makers returned from the summer of 1919, there was a subsequent fall in the popularity of 'Poppyland' as a destination. The express passenger service from King's Cross to Cromer was restored in May 1919, as were the Leicester through coaches to Yarmouth. The westbound 'Leicesters' returned in the summer of 1920 with through coaches from Lowestoft reinstated. Traffic on the Mundesley line increased, as did the service between Yarmouth and Lowestoft.

William Marriott was finally given the post of traffic manager in January 1919 (following Petrie's death the previous October), retaining his existing responsibilities. In 1920 Marriott took out patents on some of the concrete products he had introduced.

The Grouping

The Railway Act August 1921, effective from January 1923, brought nearly all of the country's railways together under just four companies. The M&GNJR continued as a

joint railway but was now under the control of the London, Midland & Scottish Railway (LM&SR) and the London & North Eastern Railway (L&NER).

Goods traffic on the M&GNJR became increasingly subject to competition from road transport in the 1920s, with fruit and potato traffic especially vulnerable. Freight was also affected by subsequent industrial and agricultural depressions. Sugar beet, though, replaced some of the agricultural losses, the weight carried increasing four-fold from 1929 to 1934; the railway served processing factories at South Lynn and Spalding. The introduction of insulated goods vans helped with the recovery of some of the fruit traffic in 1932 and 1933, and fresh flowers were carried in special trains to Spalding for forwarding by LM&SR and L&NER trains. Cabbages, broccoli and lettuces were sent to London and the provinces from the western section.

Holiday and excursion traffic increased in the late 1920s and early 1930s, and summer passenger trains variously reached destinations as far as Cheltenham, Nuneaton, Northampton, Nottinghamshire, Halifax and the West Riding. Holiday camps opened at Caister and Hemsby in 1933, with a string of small halts opened on the line from July 1933 to serve them, though some of these closed the following year due to lack of custom. A summer-only conductor-guard service was operated, which used a Sentinel-Cammell railcar for a time.

London & North Eastern Railway

1936 was a year of changes for the M&GNJR. Anticipation of another major war led to increased military traffic and the opening of a camp at Weybourne. Administration of the railway was passed to the L&NER in October 1936 (though the LM&SR retained an input to overall planning and continued to send and receive through passenger trains and freight). The motive power department moved from Derby and Melton Constable to Stratford, leading to the appearance of L&NER and ex-GNR, GER and Great Central Railway locomotives. Following these changes the works at Melton Constable were closed in December 1936, apart from some minor repair work, which had a major impact on the town. At the point of takeover by the L&NER, the M&GNJR comprised 183.5 miles of track and the N&SJR a further 22.25 miles; just over half of the railway was still single-track.

Once again, the government took control of the railways at the start of the Second World War in September 1939. Full passenger services were maintained for a few weeks to allow those on holiday to return home and for troops to reach their units, but major cuts to services followed. There were few holidaymakers during the war, the Broads and beaches were considered at risk from attack and there were restrictions on civilian travel. Several of the halts closed for the duration of the hostilities and beyond. The stations at Norwich and Gorleston North were damaged in air raids (the latter was not rebuilt and closed in 1942). Wartime production of grain, vegetables and fruit increased and created more freight, but fish traffic had declined before the war.

The 'Leicesters' returned in the summer of 1946 but to a slower schedule and without through carriages from Gloucester, Birmingham or the West Riding. The service improved the following summer with Birmingham coaches again. Services from London's Liverpool

Street also returned and in 1947 two of these trains were speeded up and named 'The Norfolkman' and 'The Broadsman' with through carriages for Sheringham via Mundesley.

The Transport Act August 1947 led to nationalisation of Britain's railways from January 1948 with the M&GNJR and N&SJR becoming part of the Eastern Region (ER) of British Railways (BR), controlled from Liverpool Street. Stations at Aylsham, Cromer, Fakenham, Murrow and Wisbech were renamed following nationalisation to distinguish the ex-M&GNJR ones from those of its former GER competitor. The rise of holiday camps led to further services and the summer halts were re-opened during 1948; the expansion of the camps continued in the 1950s but there was a decline in some holiday traffic as more visitors came by road.

Closures

The early 1950s witnessed a number of closures, including the original route to Lynn between Essendine and Bourne (June 1951), Hellesdon station (September 1952) and Mundesley to Overstrand and Roughton Road (April 1953). In September 1953 Breydon viaduct at Yarmouth was closed due to concerns about its condition and maintenance costs. This led to withdrawal of through coaches to Lowestoft on the 'Leicesters', summer Saturday trains and any still remaining local passenger services on the route. The former GER station at Cromer High was closed to passengers in September 1954 and services were diverted to Cromer Beach, which was extended to accommodate longer trains.

Diesel multiple units (DMUs) were introduced in September 1955 on some Norwich Thorpe (ex-GER station) to Cromer, Sheringham and Holt services, and on the remaining Mundesley branch in 1956. DMUs took over local services from Melton Constable to Cromer and to Norwich City (ex-M&GNJR) in September 1957. But these innovations, coupled with reducing passenger numbers, did not make sufficient savings to the cost of running the system and closures continued, despite attempts to attract summer Saturday holiday traffic. Eye Green, Thorney and Wryde stations closed to passengers in December 1957. The little-used connection from North Walsham Town to Antingham Road Junction was closed in April 1958, because of an unsafe bridge, and a new connection south of the ex-M&GNJR and ex-GER stations was in use from May 1958 until October 1960. North Drove closed to passengers in September 1958.

In May 1958 the ER (BR) proposed closing most of the M&GNJR due to financial losses. It was pointed out that four ex-M&GNJR routes duplicated those on the former GER and that nowhere on the system was more than 13 miles from an ex-GER line. Apart from Wisbech and Lynn, no intermediate station on the M&GNJR had served a population of more than 5,000. By August 1958 agreements had been reached with bus companies for replacement services. The relevant Transport Users Consultative Committees approved the proposed closures, subject to some improvements to bus services, by November 1958. The savings from closure were stated to be £640,000 a year and a further £500,000 on essential works by 1963. Nearly all the former M&GNJR system was closed as of Monday 2 March 1959, the last day for most of the services being the previous Saturday. At closure, thirty stations had been shut completely (including the goods stations at Bluestone and Langor Bridge) and a

further twenty-four closed to passengers. Track closed amounted to 79.25 miles. Passenger services between Melton Constable and Cromer Beach were retained; Sunday services ran between Cromer and Holt only.

Sections retained for goods trains included South Lynn to Rudham to serve grain and sand businesses, and Norwich City to Melton Constable. Freight on the Norwich line included building materials, roadstone, glass bottles and coal, which had to access the national network via Newstead Lane and West Runton junctions. A subsequent connection at Themelthorpe, north of Whitwell & Reepham, with the former GER line from Aylsham South (retained for goods only since 1952), saved around 20 miles of the previous journey of 64 miles from Norwich City to Norwich Thorpe (a distance of only a mile or so on foot). Themelthorpe curve opened in September 1960 and the section north to Melton Constable was then closed and lifted by 1962. Further rationalisation took place at Cromer during 1960, with closure of the line to Cromer High that had been retained for goods only and the Newstead Lane to Runton West link (so requiring reversal of all trains to Sheringham).

A new connection at Murrow between the former M&GNJR and the March to Spalding line, first used in January 1961, provided access to brickfields at Dogsthorpe and Eye Green, and Wisbech North and harbour line. The abandoned line from Wisbech Junction (Peterborough) to Dogsthorpe, via New England Bridge (known as Rhubarb Bridge) over the former MR and GNR lines, was officially closed in March 1961.

As proposed in *The Reshaping of British Railways* of March 1963 (generally referred to as the Beeching Report), the Melton Constable to Sheringham line closed to passengers in April 1964 and North Walsham to Mundesley in October the same year. Freight services to Mundesley and between Sheringham and Cromer were withdrawn at the end of the year, but those to Melton Constable were retained until December 1965, serving a sheet metal factory.

Closure of sections remaining open to freight only continued throughout the mid-1960s; Spalding to Sutton Bridge services ended in May 1965. The goods station at Hardwick Road (between South Lynn and Gayton Road) also closed in May 1965 but the line through it to East Rudham remained in use until May 1968, serving the East Anglian Grain company. The Murrow to Wisbech section closed in October 1965 (the harbour branch had been closed at the start of the year) and the connection at Murrow ended in April 1966 with closure of the brickworks.

In January 1967 the original station at Sheringham was closed (which then became redundant) and BR opened a new staffed halt east of the level crossing. The former N&SJR line from Lowestoft to Yarmouth was singled by 1967 and the daily pick-up goods withdrawn. The passenger service was withdrawn not many years after in May 1970. Norwich City closed completely in February 1969, with the loss of all remaining goods traffic, but Themelthorpe curve and the line to Lenwade remained in use until the early 1980s to serve the concrete building products company there.

The only part of the former M&GNJR still in use as part of the national railway network is the 3.75-mile line between Cromer and Sheringham, which is connected to the former GER line to Norwich via the former N&SJR Newstead Lane to Roughton Road line and the

Cromer Loop. The current Greater Anglia stations do not do much to reflect their former glory but are served by a regular service from Norwich and promoted as the Bittern Line. A new halt was opened at Roughton Road in 1985, at the site of the junction with the N&SJR.

Legacy

Closure of the greater part of the M&GNJR prompted the development of two organisations dedicated to preserving both tangible and intangible aspects of the railway. The M&GN Circle was formed in 1959 by enthusiasts wishing to share information about the history of the line and now has around 300 members. Research over the past sixty years by the Circle has resulted in a comprehensive archive of information about the M&GNJR, much of it recorded in the regular Bulletin (which has now reached some 700 editions).

The Midland & Great Northern Joint Railway Society was formed in 1959 to preserve as much as possible of the recently closed line but early plans proved too ambitious. In May 1963 a separate company, Central Norfolk Enterprises, was set up to acquire the line between Weybourne and Sheringham, which it purchased from BR in 1965. With continuing support from the Society, the by then North Norfolk Railway (NNR) opened in 1975 as a steam heritage railway. The NNR has since then extended towards Holt (the original station site was lost to road development) and reinstated the level crossing at Sheringham for occasional use by special trains.

Based on the Melton Constable to Norwich line, the Whitwell & Reepham Railway Preservation Society is working to restore the station of the same name to a condition reflecting the 1930s and 1940s. Whitwell & Reepham station re-opened to the public in February 2009, just short of fifty years after closure. Despite some planning restrictions on the site a railway heritage centre and museum have been established, situated on the Marriott Way walking and cycling route.

Beyond the confines of the two heritage railways noted above, there is still much physical evidence of the M&GNJR and N&SJR lines to be found, despite the inevitable losses to housing, commercial, and road developments. Some of this can be enjoyed from the Marriott's Way that uses the trackbed between Norwich and Themelthorpe and the Weaver's Way from south of North Walsham as far as Stalham. The Great Eastern Linear Park follows a section of the N&SJR line north from Lowestoft.

Running through relatively flat countryside, the M&GNJR had a great number of level crossings, over 150 of them by 1893, two-thirds of which were served by a crossing-keeper's cottage. Many of these gatehouses have survived in domestic use, often extended, as have some of the station houses and other buildings. Elsewhere, the remains of bridges and even boundary fences can be traced. I have included examples of these remnants in the images that follow and hope you may be inspired to seek out these and others in the countryside, while respecting privacy and private property as appropriate.

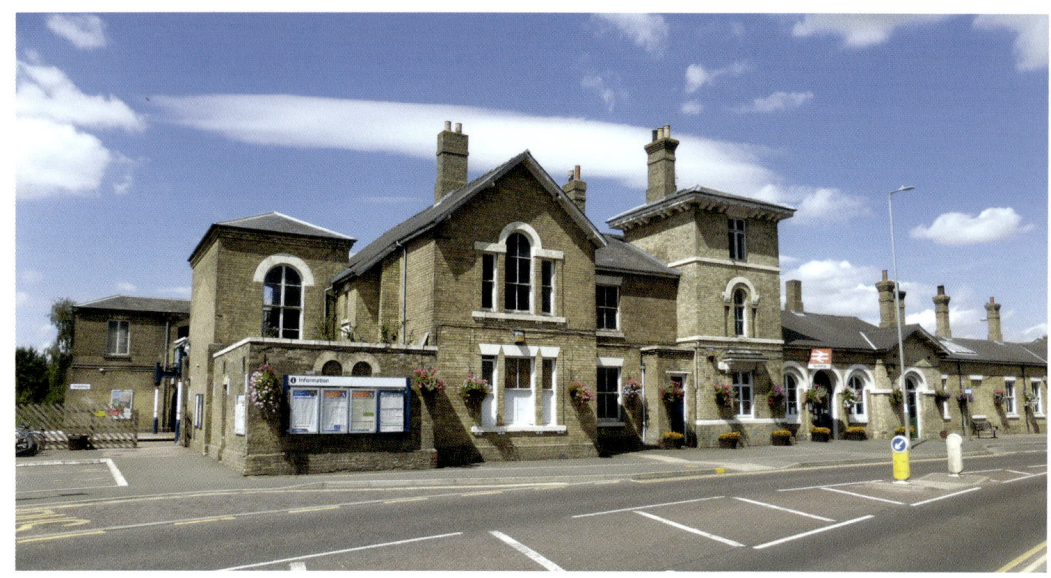

The first section of the M&GNJR, the Norwich & Spalding Railway (N&SR), began its service from Spalding on 15 November 1858. The station was opened by the Great Northern Railway (GNR) on 17 October 1848 and at one time had GNR lines to Peterborough, Boston, Sleaford and March. (Author)

BR-built Ivatt 4MT Class 2-6-0 No. 43060 (then allocated to 40F Boston shed) at Spalding during February 1959, shortly before M&GNJR passenger services were withdrawn. The Grade II listed station remains open and is to be restored by East Midlands Trains. (T. Heward/Colour-Rail.com)

The N&SR line ran south and then east from Spalding station to cross the River Welland first by bridge No. 201 (now removed) and then, following flood relief works in 1953, over the Coronation Channel. This bridge remains (at grid ref. TF 259222) but in August 2018 was not accessible. (Author)

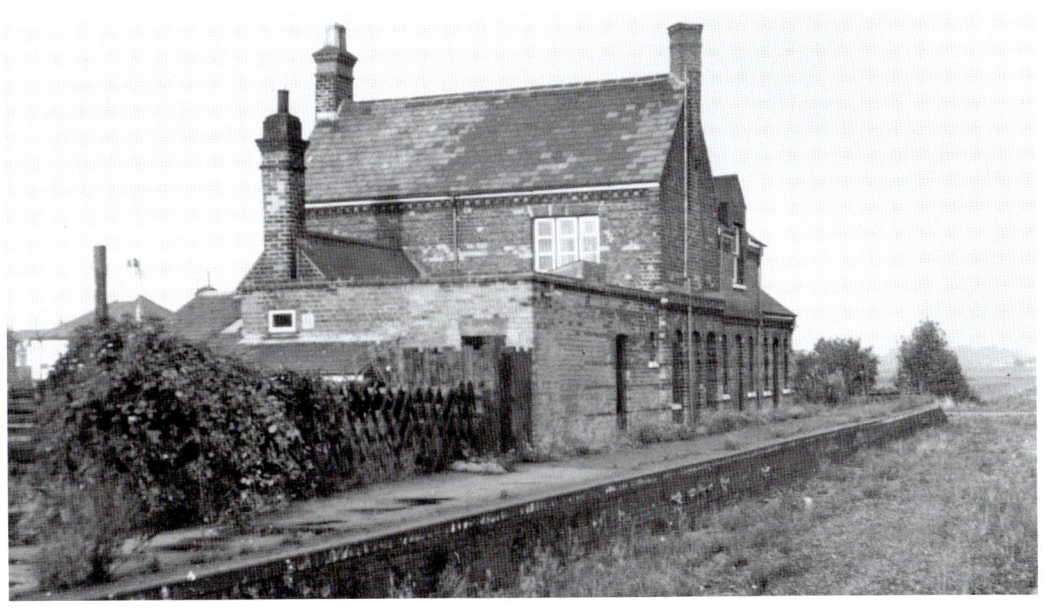

Moulton was opened by the N&SR on 15 November 1858; a goods shed was provided in the 1860s. It remained open for goods until it was closed completely on 5 April 1965. The main building on the Down platform (which still survives) is seen here in September 1967. (R. M. Casserley, courtesy of Margaret Casserley)

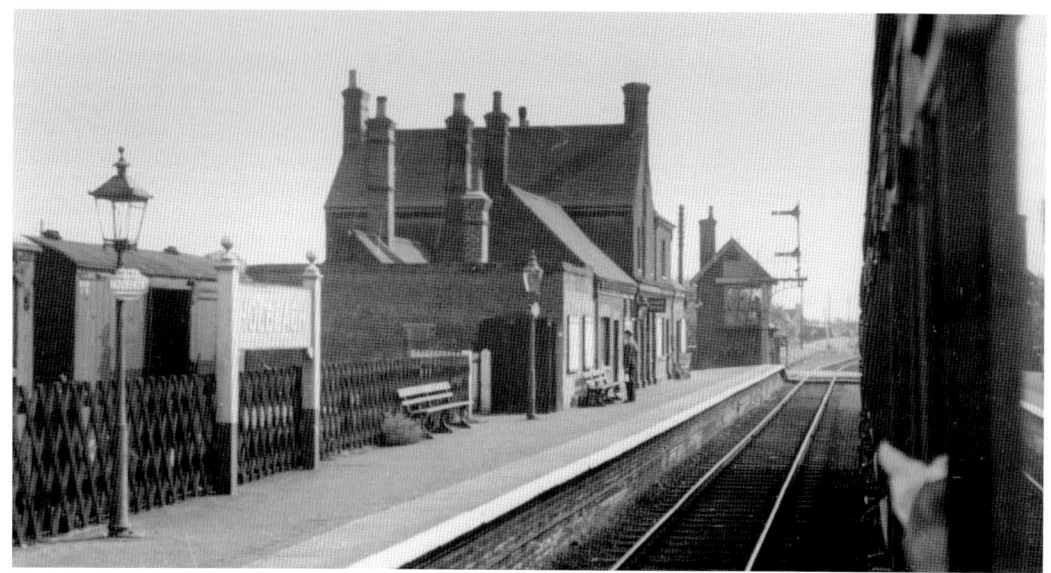

Holbeach station was opened at the same time as Moulton and was of similar design but was enlarged from 1880 onwards. The Down platform, with its station buildings and signalbox, is seen in September 1955. The main building has survived, now surrounded by new housing. (H. C. Casserley, courtesy of Margaret Casserley)

The station at Fleet was opened with one platform on 3 July 1862, on extension eastwards of the N&SR, and remained single-line. Seen in September 1967, some two years after final closure, are the station building and adjacent goods shed on the Down platform, which survive. (H. C. Casserley, courtesy of Margaret Casserley)

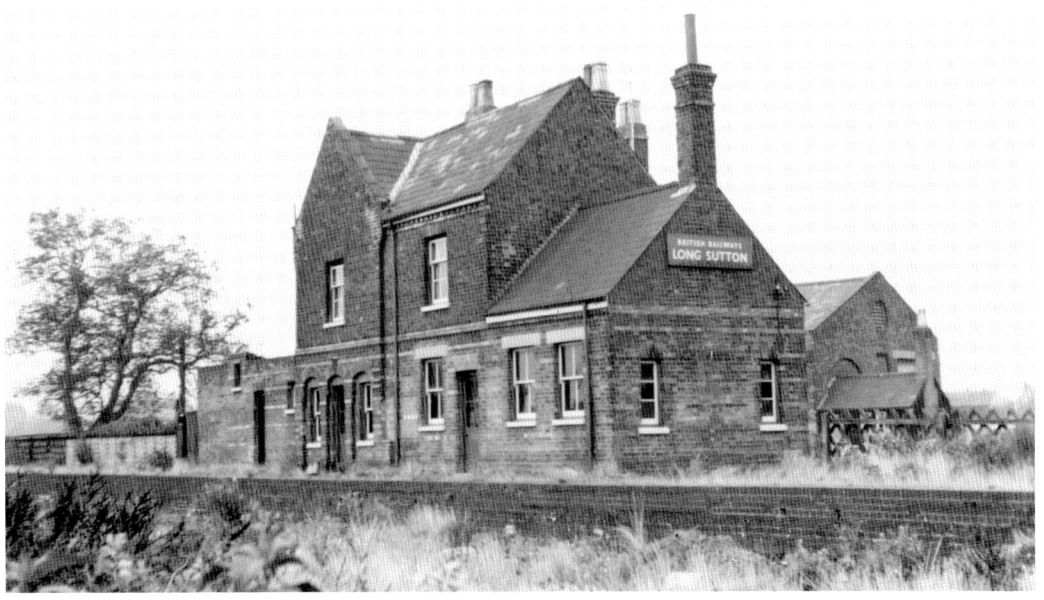

Gedney station was very much like that at Fleet, which opened at the same time, but the goods shed at Gedney was further from the station buildings. The derelict station building on the Down platform, recorded in September 1967, was being restored at the end of 2018. (R. M. Casserley, courtesy of Margaret Casserley)

Recorded on the same day in 1967 as the stations at Moulton, Fleet and Gedney, the station building on Long Sutton's Down platform still displays a nameboard. The station building dates from c. 1880, when the passenger facilities were improved. Nothing now survives. (R. M. Casserley, courtesy of Margaret Casserley)

21

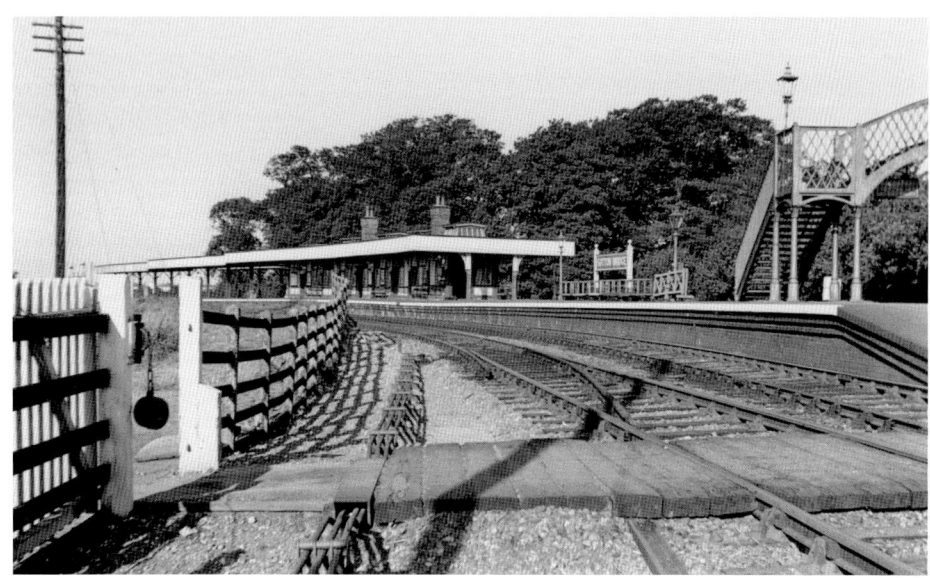

Sutton Bridge station seen from the east in September 1955. This was the third station at Sutton Bridge. The second station opened when the Lynn & Sutton Bridge Railway (L&SBR) had crossed the River Nene in 1866. The final station opened in 1897. (R. M. Casserley, courtesy of Margaret Casserley)

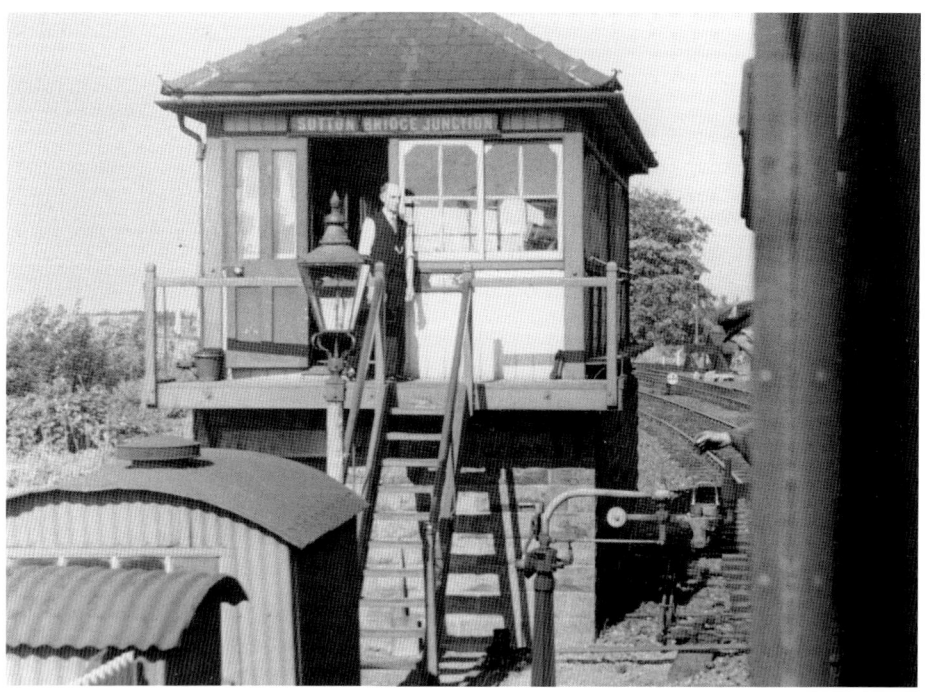

An Up train for Peterborough approaches Sutton Bridge Junction signalbox, in August 1950, while the signalman waits to retrieve the token from the Whitaker exchange apparatus. The signalbox was erected in 1881 and remained in use until April 1961. (H. C. Casserley, courtesy of Margaret Casserley)

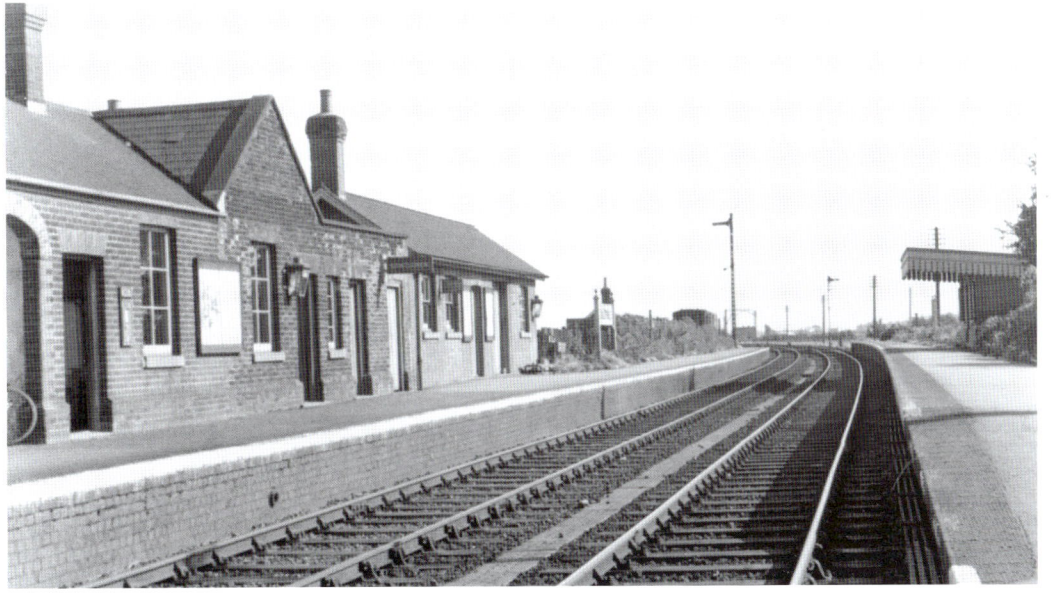

The surviving swing bridge at Sutton Bridge was constructed and erected by A. Handyside in 1897. It was originally operated by hydraulic machinery but is now powered electrically. It remains in use for road transport, having been adapted to accommodate higher vehicles. (Author)

Walpole station, recorded in October 1958, showing the Down platform left and station buildings with the combined porter's room and tariff shed of 1898 beyond. Nothing now remains, the site being underneath the dual carriageways of the A17 road. (F. Church/Casserley Collection, courtesy of Margaret Casserley)

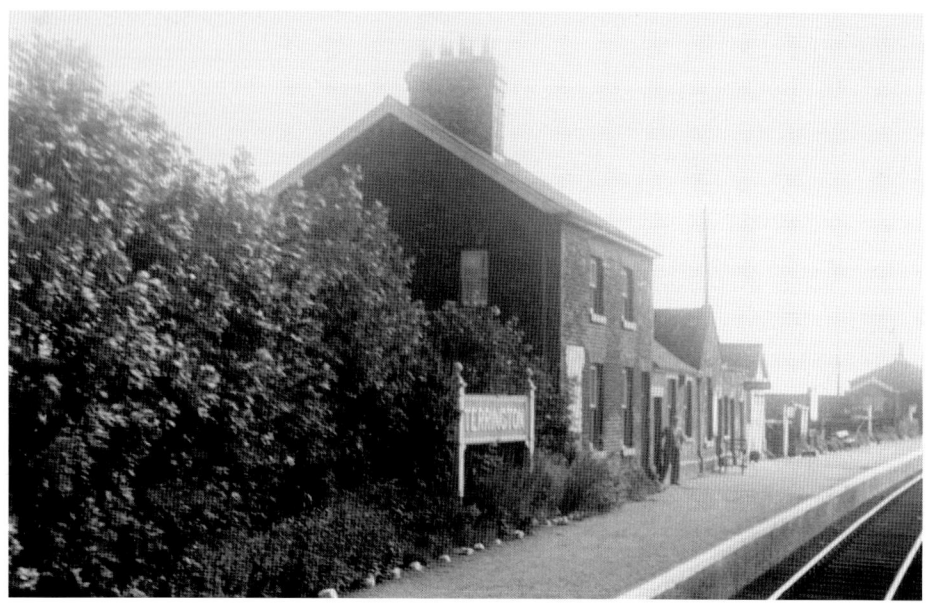

Opened at the same time and similar to Walpole, the station at Terrington became a passing place in 1890 and the track was doubled in 1899. This September 1955 view shows the station house and building, and the goods shed beyond the Down platform. This site has also been lost to the A17. (R. M. Casserley, courtesy of Margaret Casserley)

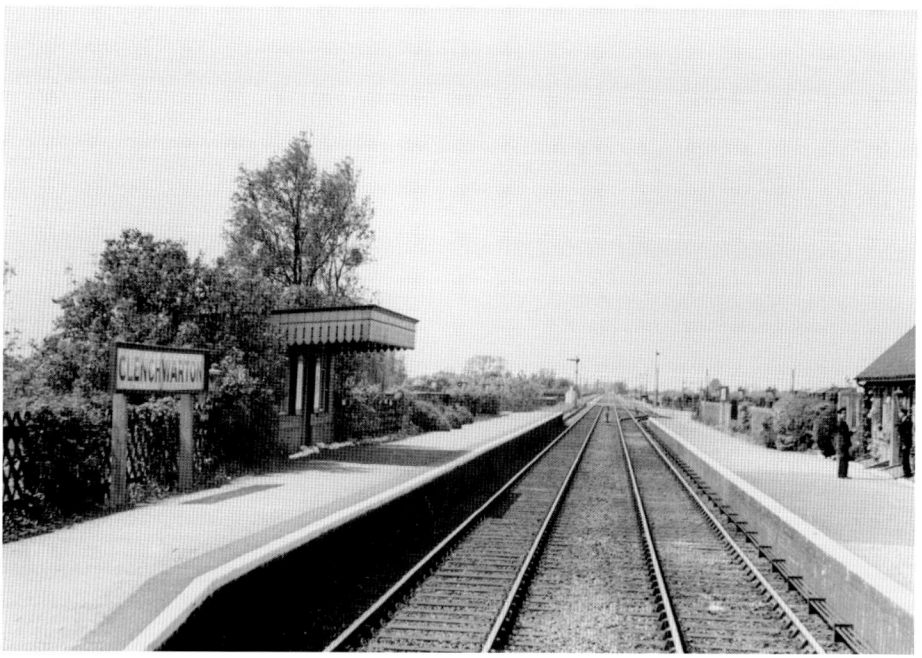

Clenchwharton station is seen in this May 1938 view looking west along the long straight towards Sutton Bridge. Doubling of the single track was completed in December 1898. The later Up platform was provided with a shelter. Clenchwharton was another victim of the A17. (H. C. Casserley, courtesy of Margaret Casserley)

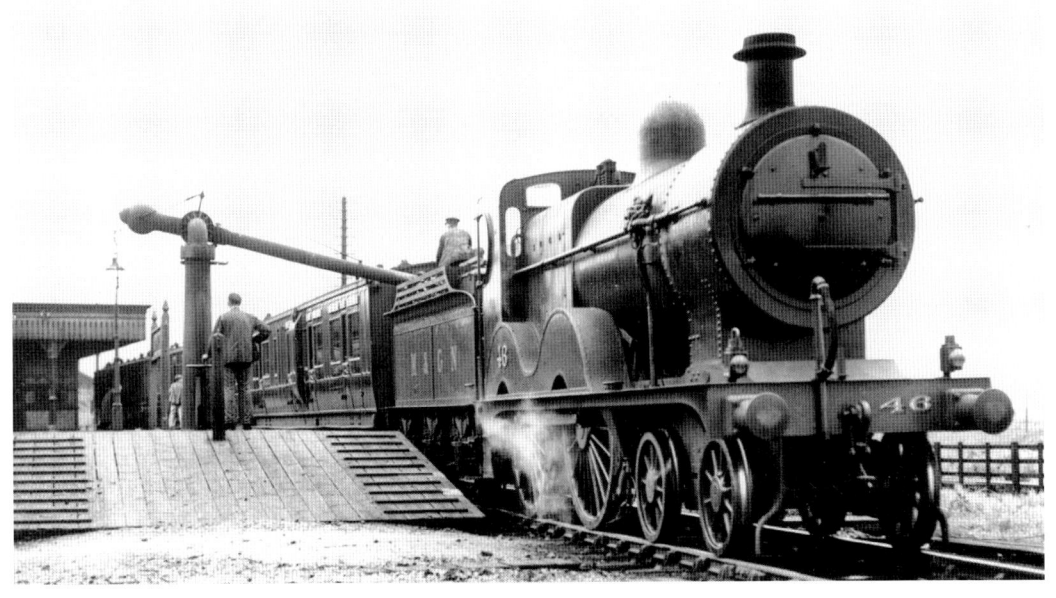

The five lattice girder spans of the West Lynn bridge (No. 46) over the Great Ouse river was completed in 1864. Despite strengthening works in 1898, a speed limit was imposed. This May 1937 view is looking west from the South Lynn bank. (H. C. Casserley, courtesy of Margaret Casserley)

M&GNJR C Class 4-4-0 No. 46, built by Sharp Stewart in 1894, stands at South Lynn with the 4.50 King's Lynn to Peterborough train in June 1936. The locomotive was rebuilt with a G7 boiler in 1915 and withdrawn in 1943. (H. C. Casserley, courtesy of Margaret Casserley)

25

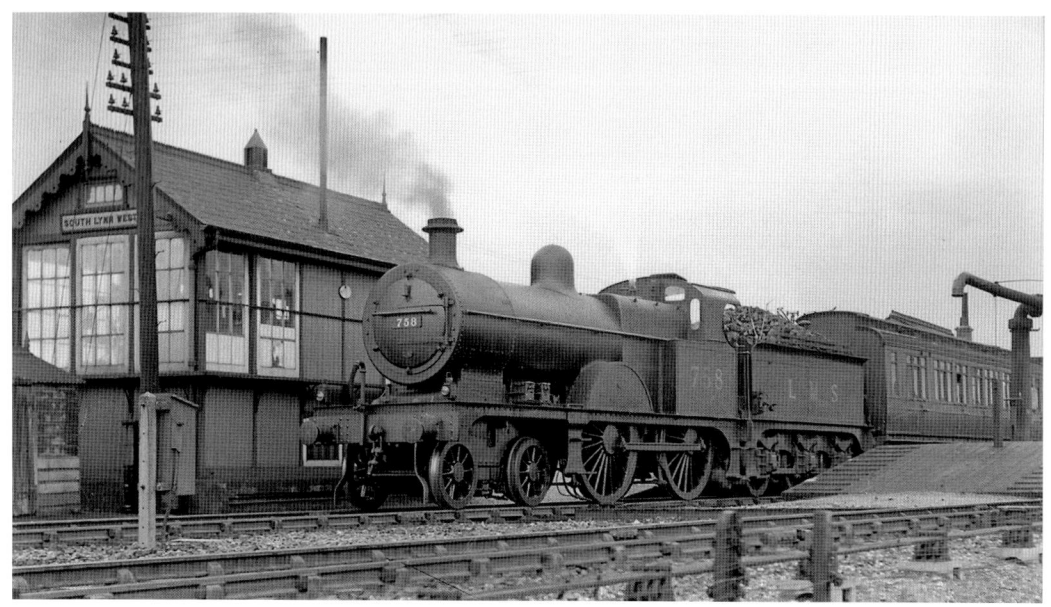

LMS 3P Class 4-4-0 No. 758 (built by MR in 1904 and withdrawn in 1951) stands by South Lynn West signalbox with the 9.00 Yarmouth to Leicester train in June 1936. (H. C. Casserley, courtesy of Margaret Casserley)

One of nine 0-6-0 tank locomotives built at the Melton Constable works between 1897 and 1905 is seen at South Lynn yard in April 1947, the later fitted bunker hopper prominent. Originally No. 2A (later No. 94), it was allocated No. 8488 by the L&NER in 1946 and withdrawn in January 1948. (H. C. Casserley, courtesy of Margaret Casserley)

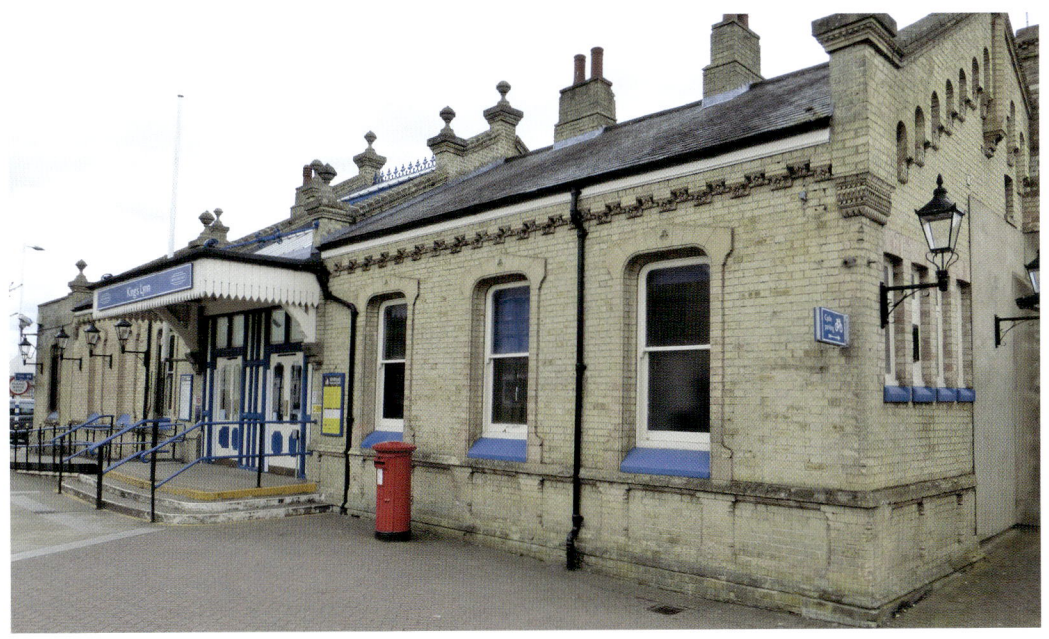

Ex-L&NER N7/2 Class 0-6-2T No. 69698 (built 1927) stands at South Lynn on the last day of M&GNJR services on 28 February 1959. This engine (with No. 69694) was a regular on the King's Lynn shuttle service, introduced when many through trains used the Bawsey loop. (Colour-Rail.com)

The first, wooden, station at Lynn (King's Lynn from 1888) was opened in 1846 and rebuilt for the GER during 1871–72. The Lynn & Fakenham Railway was given running powers into the GER station in 1879. The station was refurbished in 2014 and is seen here in April 2018. (Author)

A general view of King's Lynn station in April 1947 with L&NER F3 2-4-2T No. 7143 (built by the GER in 1902) on pilot duty. All through services on the M&GNJR used the station until the Bawsey loop was opened to passenger services in 1885. (H. C. Casserley, courtesy of Margaret Casserley)

Ex-L&NER C12 Class 4-4-2T No. 67374 (built in 1899 by the GNR) on the 9.33 shuttle service to South Lynn in September 1955. The locomotive transferred to King's Lynn shed in 1951 and was withdrawn in 1958. (H. C. Casserley, courtesy of Margaret Casserley)

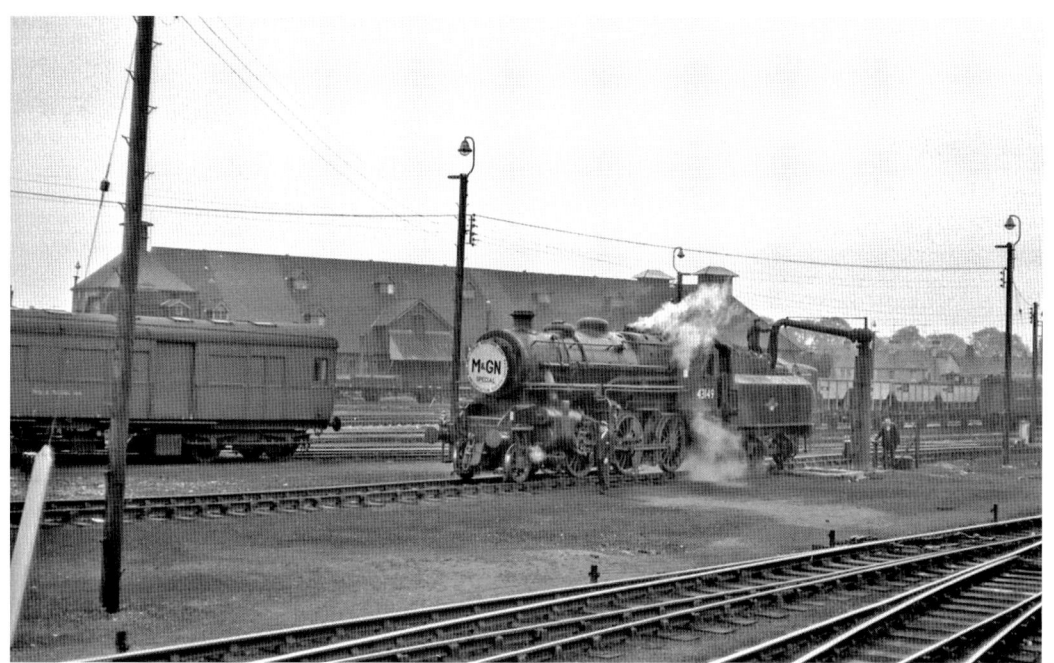

The fourth fundraising railtour organised by the Midland & Great Northern Joint Railway Preservation Society originated at Cambridge. The special brought BR-built Ivatt 4MT Class 2-6-0 No. 43149 (then allocated to 31A Cambridge shed) to King's Lynn on 26 May 1962. (Colour-Rail.com)

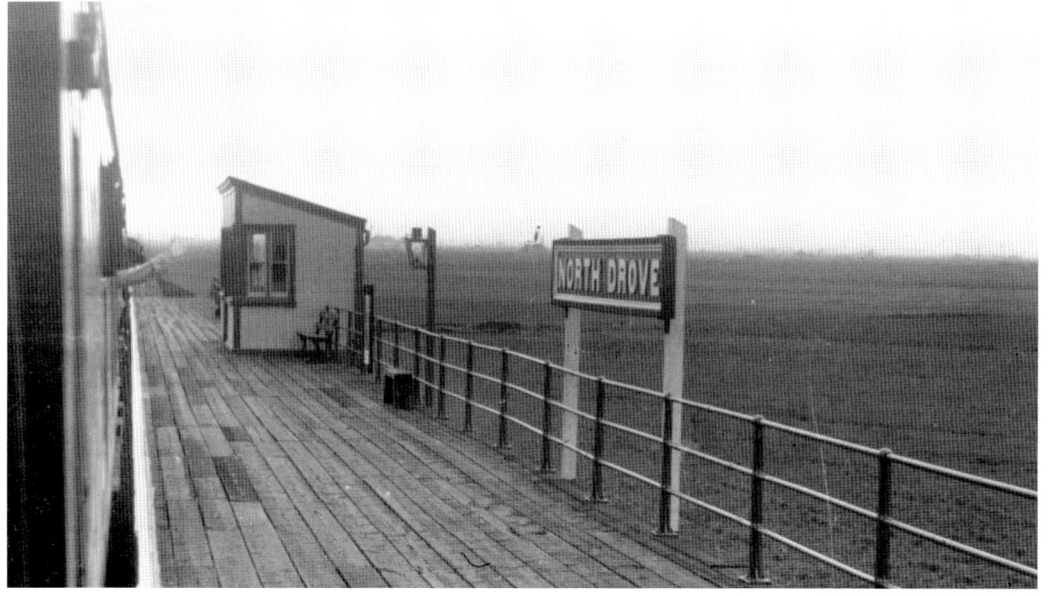

North Drove opened on 1 August 1866 as a single-platform station with the expansion westwards of the Spalding & Bourne Railway (S&BR). When the line to Saxby was opened the track was straightened and a new wooden platform, seen here in May 1956, was in use from August 1894. (R. M. Casserley, courtesy of Margaret Casserley)

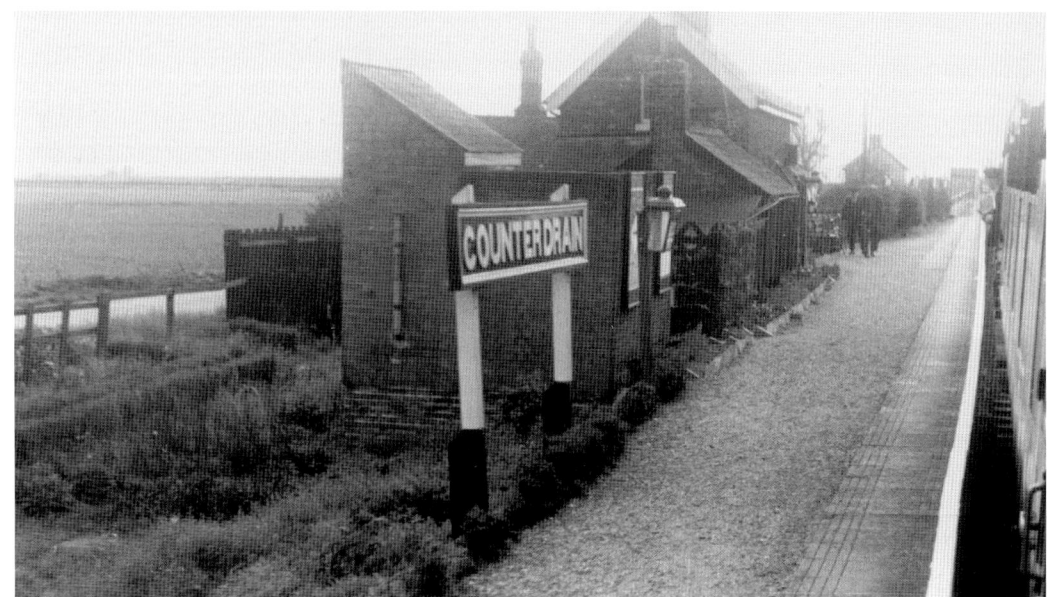

The typical S&BR station building at Counter Drain is seen from the same train as North Drove in May 1956. The bay window in the station building overlooking the platform can just be seen. The nearby crossing gatehouse (No. 105A) and girder bridge (No. 223) have survived. (R. M. Casserley, courtesy of Margaret Casserley)

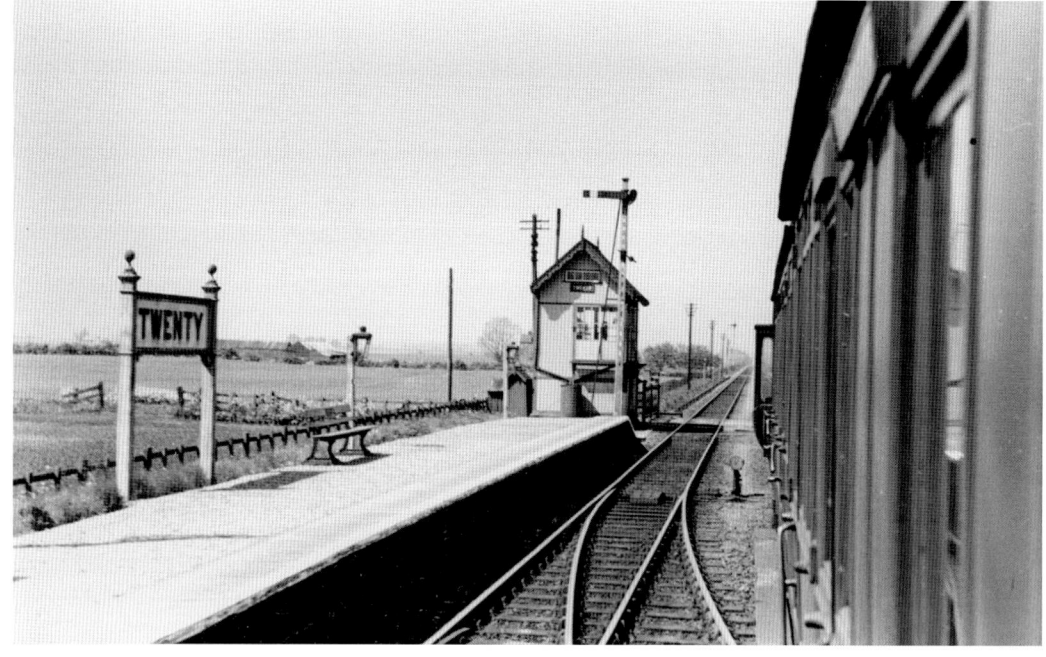

The signalbox is prominent at the west end of the Up platform of Twenty station in this May 1937 view. The only S&BR station not demolished after the line closed completely on 5 April 1965, the much-altered building survives at the end of Station Road. (H. C. Casserley, courtesy of Margaret Casserley)

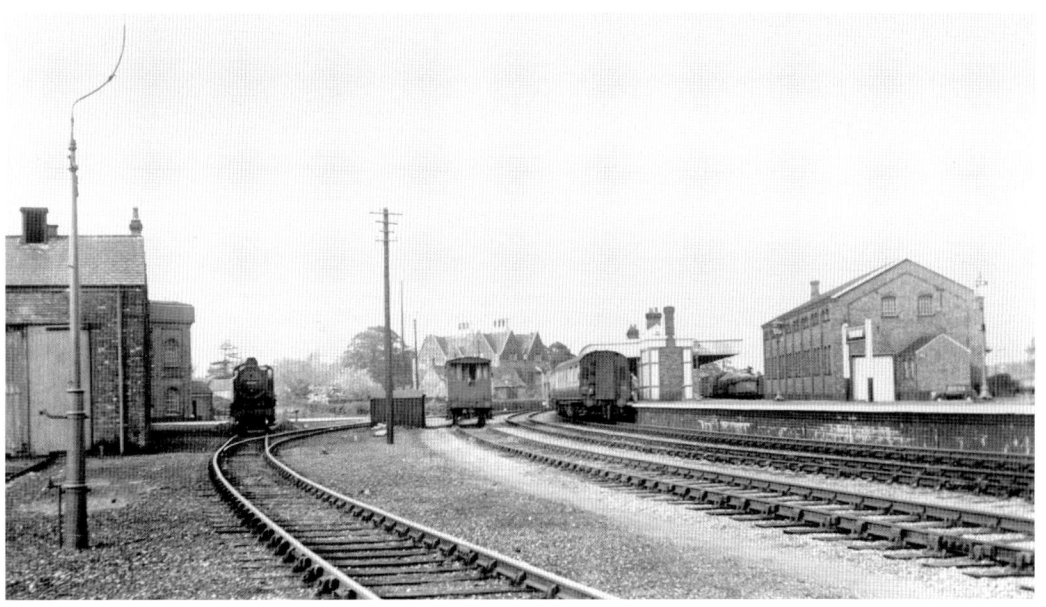

LMS 2P Class 4-4-0 No. 404 (allocated to 16A Nottingham shed) stands at Bourne with the 6.40 train to Nottingham on 28 May 1937. The engine was built by the MR in 1892 and withdrawn in 1957. Bourn (officially Bourne from 1893) was reached by the S&BR on 1 August 1866. (H. C. Casserley, courtesy of Margaret Casserley)

A wider view of Bourne station in May 1956 looking towards Spalding. The station opened in May 1860 and gave the future M&GNJR access to the GNR at Essendine. A further GNR line to Sleaford opened in January 1872. The Red Hall is in the middle distance. (R. M. Casserley, courtesy of Margaret Casserley)

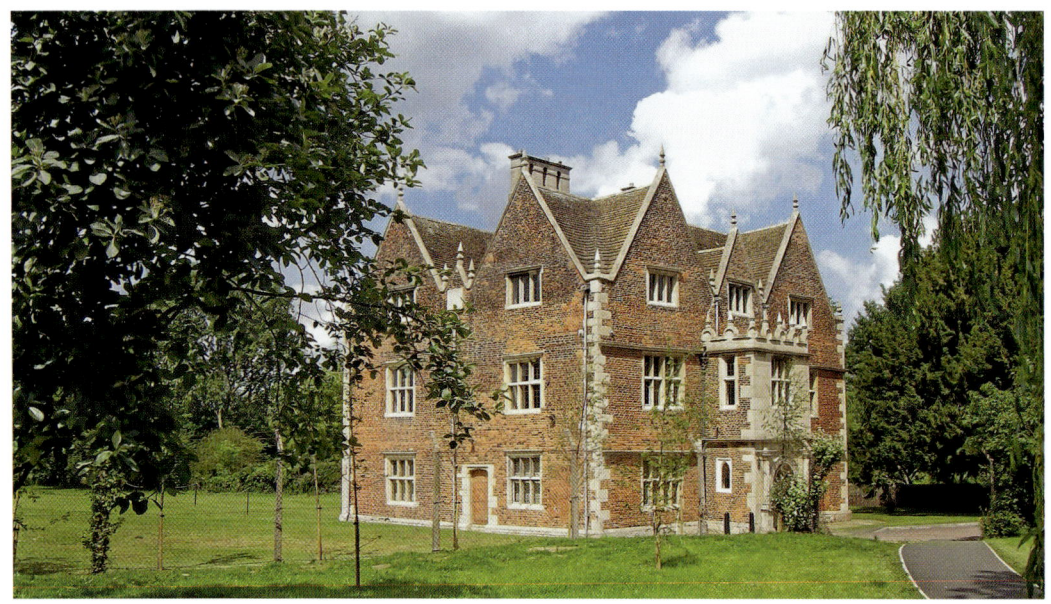

The Red Hall was built in 1605 as a country residence. In 1860, by then a private school, it was sold to the newly arrived railway and used as a booking office and stationmaster's house. It survived closure of the railway and is now home to Bourne United Charities. (Rex Needles)

The GNR station at Peterborough North opened on 7 August 1850, to which the Peterborough, Wisbech & Sutton Bridge Railway (PW&SBR) ran from 1 August 1866. Ex-M&GNJR locomotives DA Class 0-6-0 No. 083 and C Class 4-4-0 No. 044 have arrived with the 12.10 Cromer to King's Cross on 20 May 1938. (H. C. Casserley, courtesy of Margaret Casserley)

BR-built Ivatt 4MT Class 2-6-0 No. 43111 was delivered new to South Lynn shed (31D) in July 1951. The engine was reallocated to Boston (40F) in March 1959. It is seen here at the north end of Peterborough North *c.* 1958 with Spital Bridge beyond the signals. (Colour-Rail.com)

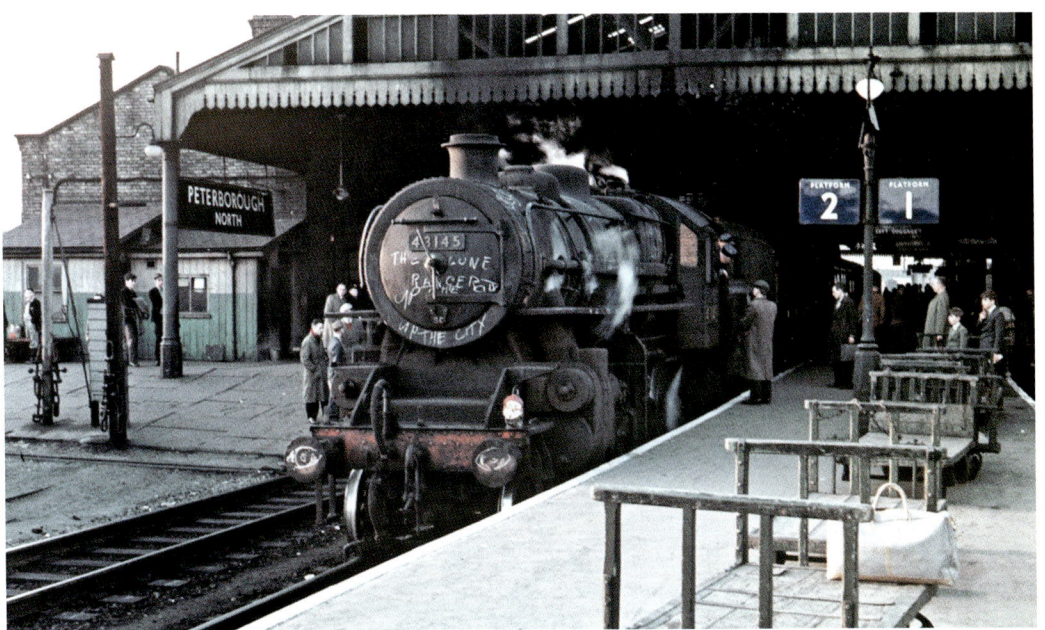

The 12.56 from Yarmouth Beach stands at Peterborough North on 28 February 1959, the last day of M&GNJR passenger services. The locomotive, Ivatt 4MT Class 2-6-0 No. 43145, had been delivered new to Yarmouth Beach (32F) shed in September 1951. (Colour-Rail.com)

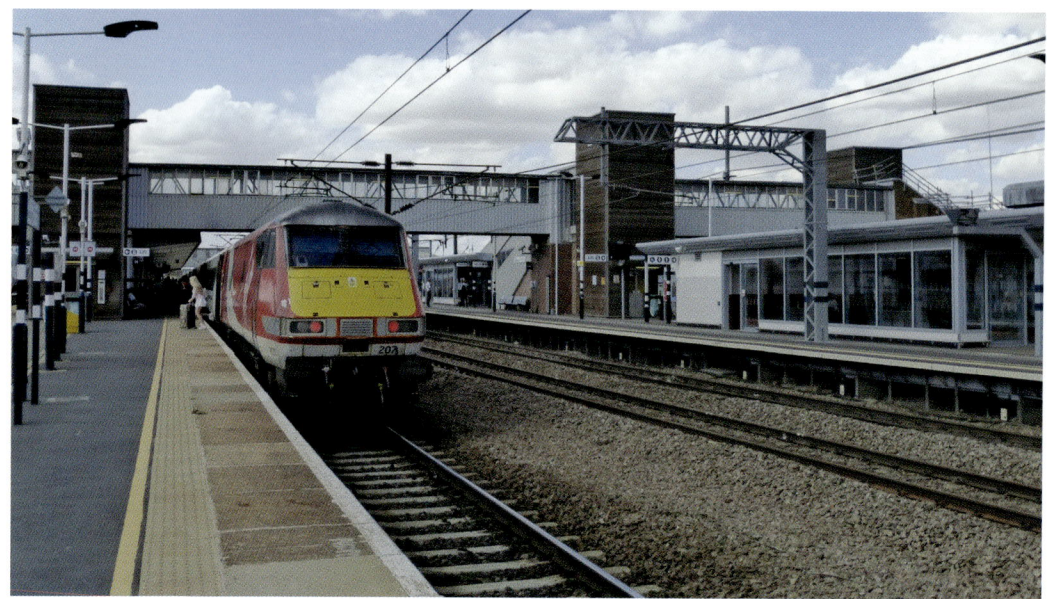

Peterborough station has been substantially rebuilt with additional platforms and nothing of the M&GNJR remains. An express from King's Cross has arrived behind BR Class 91 No. 91121 (with DVT No. 82207 trailing) in August 2018; London is one of many destinations served. (Author)

Nothing remains of Eye Green station, on the PW&SBR line from Peterborough, now lost beneath the A47 dual carriageway. Further east, an M&GNJR concrete hut marks the site of Mill Hill Road crossing, seen in August 2018, but gatehouse No. 78 has been demolished. (Author)

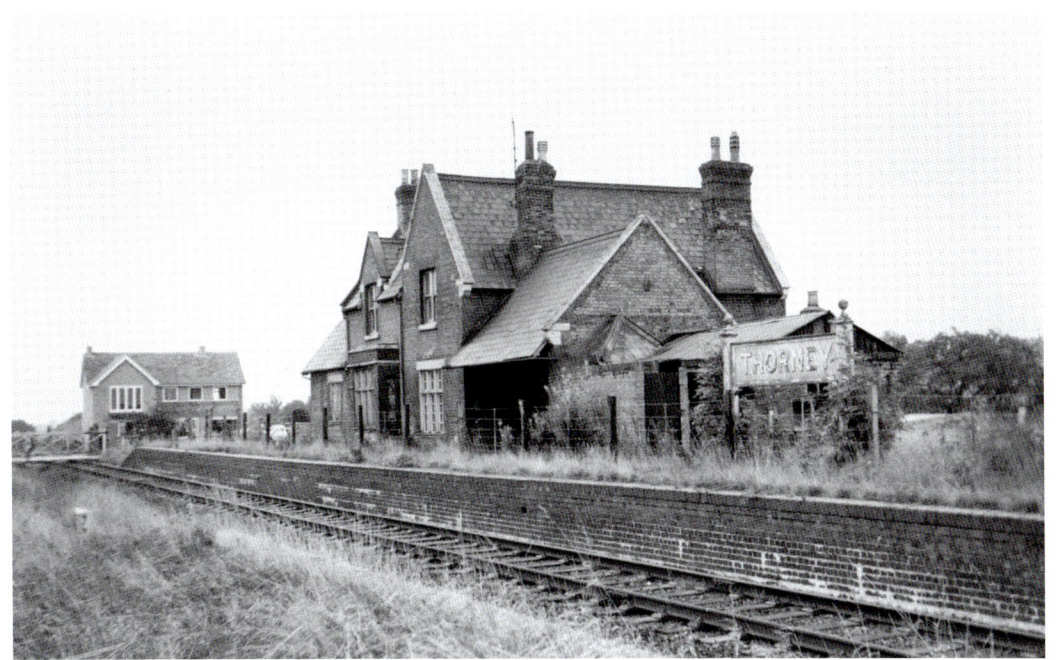

Thorney station, built to the larger PW&SBR design, opened on 1 August 1866 with a single platform. A passing loop and second platform were provided around 1875 and were remodelled following doubling in February 1900. The station buildings on the Up platform are seen in September 1967. (R. M. Casserley, courtesy of Margaret Casserley)

Nothing remains of Thorney station, which remained open for goods until April 1966, the whole site being demolished after 1995. Replica crossing gates mark the location of Thorney station on the west side of Station Road, seen here in August 2018. (Amber-Ruth Watson)

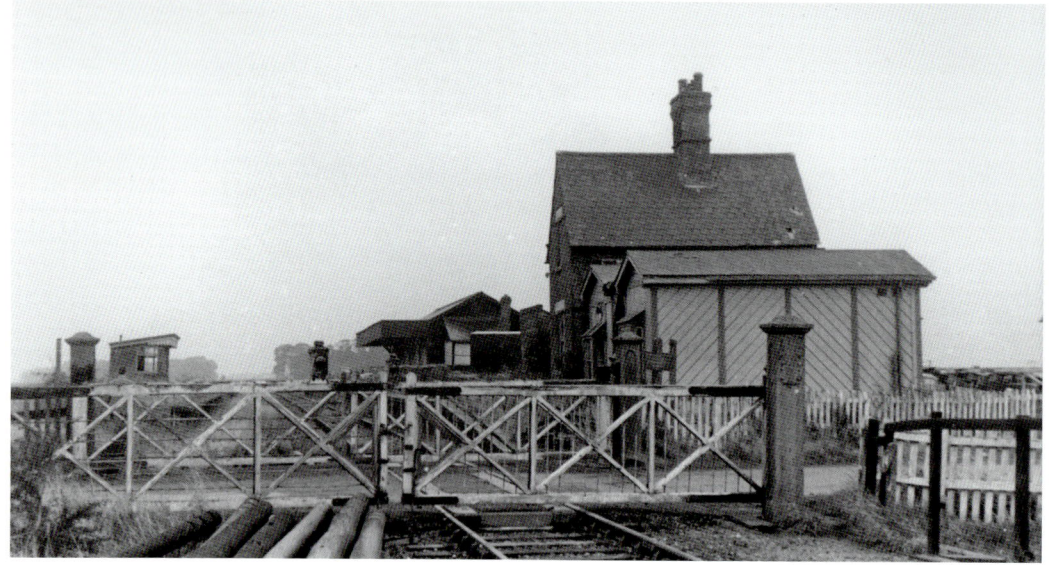

The level crossing on the B1177 New Cut road at Wryde station is closed to railway traffic in this post-closure view towards Wisbech of September 1967 date. Note the unusual timber booking hall and waiting room in front of the station building and goods shed beyond. (H. C. Casserley, courtesy of Margaret Casserley)

The station buildings at Wryde survived, in poor condition, until the 1980s but have since been demolished. The tarred timber grain and goods shed of 1891 still survives, albeit in poor condition, and the site has been cleared of the former scrapyard, as seen here in August 2018. (Amber-Ruth Watson)

Taken from an old postcard, this view looking south from Murrow Bank of Murrow shows the level crossing, with the road to Ring's End beyond, and signalbox (presumably the earlier MR-type replaced in 1892). The station was to the right. (Author's collection)

Murrow station was of the smaller PW&SBR design, as also at Wryde, Ferry and Tydd, and opened on 1 August 1866. The line was doubled by February 1901. Just to the west, beyond this September 1967 view, the Great Northern & Great Eastern Joint Railway crossed on the level. (R.M. Casserley, courtesy of Margaret Casserley)

37

Nothing remains of the M&GNJR station at Murrow, but the GN&GEJR goods shed from Murrow West survives within a reclamation business, viewed with permission in August 2018. Goods services continued to Murrow East until 1965; the GN&GEJR line survived until 1982. (Author)

A new signalbox was opened at Murrow West on 26 November 1950, to replace one demolished in 1941 when two trains collided on the flat crossing. This brick and concrete structure survives in a much-extended state as a private residence, seen here in August 2018. (Amber-Ruth Watson)

The platform shelter and signalbox at Wisbech St Mary on the Down platform, looking east from a passing train in August 1950. The station continued to receive goods via Peterborough until December 1960, and then via the link at Murrow for another four years. No trace of the station now remains. (H. C. Casserley, courtesy of Margaret Casserley)

Wisbech St Mary station was built to the larger PW&SBR design, similar to those at Eye Green and Thorney, but the station house was extended in 1898 with a first floor added over the booking hall. The redundant buildings are seen from the station yard in September 1967. (R. M. Casserley, courtesy of Margaret Casserley)

The Down platform at Wisbech station (with 'North' added to distinguish it from the former GER station) viewed in August 1950 with the MR-type signalbox and footbridge just visible beyond the end of the train. The wooden platform shelter was open-fronted in 1903. (H. C. Casserley, courtesy of Margaret Casserley)

Looking north towards the site of the level crossing at Wisbech, the former station buildings, shelter and water tank on the Up platform are seen in September 1967. The timber station buildings were perhaps intended to be temporary structures but were never replaced. The site is now buried under housing. (H. C. Casserley, courtesy of Margaret Casserley)

The former M&GNJR goods offices at Wisbech on Leverington Road (grid ref. TF 456104) survives in commercial use, as seen in August 2018. This building was constructed in 1899. The extension to the left originally housed toilets and a 'heating chamber'; the porch is a more recent addition. (Author)

Ferry station building, opened on 1 August 1866, was originally provided with a platform alongside, but a new brick platform was built opposite and the track re-aligned to this by 1886. The station house, seen here in September 1967, survives in residential use as the only remaining structure. (H. C. Casserley, courtesy of Margaret Casserley)

The station building at Tydd was of the same smaller PW&SBR design seen at Ferry, Murrow and Wryde but was provided with a ladies' waiting room in 1891. Seen here following closure, there have already been some additions to the building; by 1967 a substantial extension had been added and very little of the original now remains. (H. C. Casserley, courtesy of Margaret Casserley)

An Ivatt 4MT Class 2-6-0 locomotive is at Yarmouth Beach on the last day of passenger services on 28 February 1959. The station opened in 1877 with services running to Stalham by 1880. Improvements at the station included a lengthy canopy (in 1882) and a third platform. (D. B. Swale/Colour-Rail.com)

M&GNJR A Class 4-4-0 No. 29 receives attention at Yarmouth Beach on 25 June 1929 before leaving with the 8.08 to Lowestoft Central. The locomotive was built for the Eastern & Midland Railway in 1886 by Beyer Peacock, reboilered in 1906 and withdrawn during 1931. (H. C. Casserley, courtesy of Margaret Casserley)

M&GNJR locomotives at Great Yarmouth in June 1929. D Class 0-6-0 No. 59 (built in 1896 by Neilson & Co. to a MR design by S. W. Johnson) stands in front of the loco shed while C Class 4-4-0 No. 78 (built 1899) is inside. No. 59 was withdrawn in June 1944 while No. 78 lasted until February 1937. (H. C. Casserley, courtesy of Margaret Casserley)

The first of three A Tank Class 4-4-2T locomotives constructed at Melton Constable works, No. 41 is seen on the 60-ft turntable at Yarmouth Beach in May 1937. The engine was built in 1904 and survived until the beginning of 1944 (as L&NER No. 041). (H. C. Casserley, courtesy of Margaret Casserley)

M&GNJR Melton Class 0-6-0T No. 16 (built 1905 and withdrawn 1949) on station pilot duty at Great Yarmouth (Beach) in May 1937 alongside the platform starting signals. After closure the station was used as a bus station before demolition in 1986 and the site is now a car park. (H. C. Casserley, courtesy of Margaret Casserley).

Caister Camp halt seen in September 1955 with the Caister Camp Café behind. The simple sleeper platform here was replaced with a longer one at normal height in 1934, which allowed express trains to call. There are now no remains to be seen. (D. Thompson/Casserley Collection, courtesy of Margaret Casserley)

The tiny California halt was opened on 17 July 1933, along with six other similar ones, in an effort to attract holiday camp traffic from competing road transport. The halts were all on the Down (seaward) side of the line, as in this September 1955 view. (R. M. Casserley, courtesy of Margaret Casserley)

A very neat looking Down platform at Great Ormesby station, seen facing Melton Constable in May 1937. The noticeboards advertise holidays in North Wales and Woodhall Spa. The station building survives, and this shelter is preserved at Mangapps Railway Museum in Essex. (H. C. Casserley, courtesy of Margaret Casserley)

This Victorian tableau at Martham station, looking towards Yarmouth, includes former Eastern & Midlands Railway 2-4-0 No. 13. Purchased from the Cornwall Minerals Railway as a 0-6-0 tank engine, it was converted in 1892 to the form seen here. (Casserley Collection, courtesy of Margaret Casserley)

Another of the tiny halts opened in 1933, Potter Heigham Bridge was located on the north side of the River Thurne and reached by a steep path from the riverbank. The three girder spans of Potter Heigham bridge (No. 155) were immediately south of the halt, seen here in September 1955. (R. M. Casserley, courtesy of Margaret Casserley)

Potter Heigham station opened on 17 January 1880 and was provided with a brick-built Wilkinson & Jarvis 'office' design building, seen far left at the end of the Up platform with the level crossing beyond. The passing loop was installed in 1898. This is another September 1955 view. (R. M. Casserley, courtesy of Margaret Casserley)

This June 1965 view of Catfield station Down platform clearly shows the 'office' type building provided by the contractors here, and at Potter Heigham and Stalham. The 1920s concrete block gate cabin is to the left. The station was demolished in the 1960s for construction of the A149, which follows the trackbed. (R. M. Casserley, courtesy of Margaret Casserley)

The Down side boundary of the empty station site at Stalham in April 2018. The station building was dismantled in 2000–01 and rebuilt at the new Holt station on the North Norfolk Railway. A planning application for housing on this site was refused in June 2018. (Author)

The Weaver's Way follows the route of the M&GNJR from Stalham towards North Walsham, passing several former gatehouses including this one (No. 31) dating from 1881 at East Ruston (grid ref. TG 346272) seen in April 2018. The brick-built structure was first extended by 1914. (Author)

The rolled iron joist bridge (No. 146) carrying the Horning Road over the former M&GNJR trackbed (grid ref. TG 328273), seen from the Weaver's Way in April 2018. The bridge was rebuilt in 1896 with decorative steel plates. (Author)

The platforms remain at Honing, with evidence of the location of station buildings, loading and cattle docks and other structures. The site had benefitted from a tidy-up at the time of visiting in April 2018, looking towards the level crossing site. (Author)

The former stationmaster's house at Honing in April 2018, which also served as the crossing gatehouse (though it was not numbered as such). The station lies behind the photographer, beyond the site of the level crossing. (Author)

Honing East signalbox controlled the whole of the layout after the closure of the East signalbox in June 1932. It was saved and rebuilt at Barton House Railway in 1967 and is preserved beside the miniature railway alongside the River Bure in Wroxham. (Mike Beale)

The brick piers of bridge No. 144 over the North Walsham & Dilham Canal (grid ref. TG 315276) west of Honing station seen in April 2018. A timber footbridge serving the Weaver's Way has replaced the steel girders sold for scrap after closure. (Author)

51

M&GNJR C Class 4-4-0 No. 55 seen near North Walsham with a passenger train (reporting no. 17) in July 1936. This locomotive was built by Sharp Stewart & Co. in September 1896. It was rebuilt with an 'H' type boiler in 1908, which was replaced in 1925 with a G7 one. (H. C. Casserley, courtesy of Margaret Casserley)

This view looking north from the Down platform in January 1964 shows North Walsham Town station largely intact. The station building on the right was of Jarvis & Wilkinson's 'large pavilion' type with enclosed steps down to road level on the right. All was cleared in 1977 for the A419 bypass. (R. Oakley/Colour-Rail.com)

Almost the first evidence of the Lynn & Fakenham Railway (L&FR) route east from King's Lynn is the timber-built gatehouse (No. 3) of 1879 at Common Road (grid ref. TF 690219). This can be found at the end of Cliffe-en-Howe Road from Pott Row village. (Author)

Gayton Road station was opened on 1 January 1886, after completion of the L&FR line to Fakenham in 1879. This view looking towards South Lynn, just over seventy-three years later, shows the shelter on the Down platform. (R. M. Casserley, courtesy of Margaret Casserley)

53

Grimston Road station was opened on 16 August 1879 by the L&FR; initially a passing place, the line was doubled in 1882. The station building, which survives in commercial use, was of the Wilkinson & Jarvis 'office' type and is seen here in April 2018. (Author)

The remains of underline bridge No. 78, near Holly Lodge between Grimston Road and Hillington stations (grid ref. TF 711249). The plate girder underbridge crossed both this lane and a stream to the right of this April 2018 view. (Author)

54

Hillington (for Sandringham) as seen in July 1936, looking towards Massingham. The waiting room can be seen on the later Down platform with the stationmaster's house behind. The signalbox was moved next to the level crossing in 1927. (H. C. Casserley, courtesy of Margaret Casserley)

The public side of the surviving Up station buildings at Hillington, seen in April 2018. The nearer, unusually built of brick rather than concrete, was to a new 'small pavilion' design by Wilkinson & Jarvis. The half-timbered 'Royal' waiting room beyond was added c. 1887. (Author)

An Up train approaches the second-hand MR signalbox and automatic tablet exchanging apparatus at Massingham in April 1947. The signalbox survives in apparently excellent condition in the station site, now private residential property, along with the station buildings and tariff shed. (H. C. Casserley, courtesy of Margaret Casserley)

Massingham station building seen from the station approach road in April 2018. The 'office' design building was the last to be made of concrete. Massingham was the terminus of the L&FR from August 1879 until the line opened to Fakenham a year later. (Author)

The station house at Massingham also survives in residential use and is also seen in April 2018 (grid ref. TF793249). Built *c.* 1881 near the level crossing, it is similar to those at Hillington and East Rudham. (Author)

Evidence of an occupation crossing just east of Massingham station (grid ref. TF 796258) still marks the route of the M&GNJR in April 2018. There are numerous small signs of the railway across the whole network. (Author)

57

The original timber gatehouse No. 9 at Kipton Heath (grid ref. TF 815249) was replaced by a concrete one in 1916, seen here in April 2018. This is one of several gatehouses to have survived along this stretch of line. (Author)

The Down platform at East Rudham station, looking back towards the passenger shelter and signalbox (just visible) in January 1959, a few months before the withdrawal of passenger services. The former Railway Hotel is partially visible behind the shelter. (R. M. Casserley, courtesy of Margaret Casserley)

East Rudham station buildings on the Up platform, seen in April 2018, at which time the property was for sale. In April 1916 the M&GNJR decided to rebuild much of the station in concrete block. The station house also survives. (Author)

Seen on the same day in January 1959 at East Rudham, the standard M&GNJR shelter is seen on the Down platform at Raynham Park. A corner of the former stationmaster's house, built in 1886 by the L&FR chairman, is just visible on the extreme left. (R. M. Casserley, courtesy of Margaret Casserley)

59

Looking south-west, towards South Lynn, through the closed station at Raynham Park station in June 1960. Much of what can be seen here survives in private ownership, including the signalbox, and is maintained in good condition. (R. M. Casserley, courtesy of Margaret Casserley)

Formerly the terminus of the L&FR in August 1880, Fakenham became a through station with the opening of the line on to Melton Constable in January 1882. This view looking south-east from the Up platform dates from September 1955. (R. M. Casserley, courtesy of Margaret Casserley)

Looking back from a departing Down train at the M&GNJR Type 1A signalbox at Thursford in January 1959. The trackbed here is now occupied by the rerouted B1354 road. Attempts by the North Norfolk Railway to dismantle and rescue the surviving goods shed were unsuccessful. (R. M. Casserley, courtesy of Margaret Casserley)

The first line to reach Melton Constable was the L&FR in December 1882, seen on the left at Melton West Junction in March 1939. Ex-M&GNJR C Class 4-4-0 No. 043 (built 1894) brings a train from Cromer on the line via Holt that opened in October 1884. (H. C. Casserley, courtesy of Margaret Casserley)

Melton Constable station's island platform is seen, looking west, in April 1947. The L&FR line through from Fakenham towards Norwich opened on 2 December 1882. This was joined by the Eastern & Midlands Railway (E&MR) line from North Walsham on 5 April 1883. (H. C. Casserley, courtesy of Margaret Casserley)

The land for the railway at Melton Constable was made available by Lord Hastings, a director of the L&FR. A condition of this was the provision of a private station, built at the west end of the station by the Up line. It is seen here, looking east, in March 1939. (H. C. Casserley, courtesy of Margaret Casserley)

A locomotive and carriage works was also established at Melton Constable in 1881, its development continuing until 1912. The range seen here on the right in June 1929 survives as part of a vacant commercial lot comprising 39,111 square feet (3,633 square metres). (H. C. Casserley, courtesy of Margaret Casserley)

The former erecting shop at Melton Constable works was renewed in 1899 and was served by three running lines. It is seen here in August 2018, still with its weathervane on the roof. The foundry stood to the right in the space now occupied by wooden potato boxes. (Amber-Ruth Watson)

The rear of the erecting (or fitting) shop seen in August 2018, showing remaining evidence of the 2 ft gauge tramway that was provided around the works site. The tramway lines were connected through turntables and allowed heavy items to be moved around on trolleys. (Amber-Ruth Watson)

The roof of the original three-road engine shed at Melton Constable collapsed in December 1946 and was replaced by 1951 with a simpler brick and concrete structure, later given BR code 32G. Seen in August 2018, it was serving as the prosaically named 'Flat Roof Store'. (Amber-Ruth Watson)

The water tank (constructed 1898) at the north-west corner of the site held 100,000 gallons (454,609 litres) and provided for the village as well as the works. It survived minor damage during the Second World War and its (now enclosed) base was in use as a grain store in August 2018. (Amber-Ruth Watson)

The former goods shed at Melton Constable, with beer store beyond, seen from the road in August 2018. A gas lamp also survives within the yard area. Goods services continued until the end of 1965. (Amber-Ruth Watson)

The Railway Institute began as the 1880s, single storey Railway Hall. It was extended with a second floor to open as the Melton Institute in 1896, receiving a further extension in front in 1912. It was taken over by Melton Constable Country Club as the only social building locally. (Author)

The Jarvis & Wilkinson brick-built 'small pavilion' style station building at Hindolvestone station, looking north in January 1959, with the tariff shed beyond. The L&FR station here opened on 19 January 1882. (R. M. Casserley, courtesy of Margaret Casserley)

The station building at Hindolvestone (adapted for residential use in 1979) survives as dwelling, as do the nearby railway cottages on Station Road. Seen from the approach in August 2018, the station buildings and surrounds were for sale in June 2019. (Author)

The gatehouse (No. 17), left, and gate cabin at Hindolvestone crossing south of the station, as seen from an adjacent field in August 2018. The brick-built gatehouse dates from 1881 but was extended by 1901. The cabin is believed to be *c.* 1895. (Author)

The single platform at Guestwick station seen in January 1959. The M&GNJR Type 1A signalbox was constructed in 1895 but was rebuilt post-1945 with a brick base. It survives in good condition within a residential property. (R. M. Casserley, courtesy of Margaret Casserley)

Guestwick station building was built in the Wilkins & Jarvis 'small pavilion' style but with high door and window arches with keystones. Seen from the former public side in August 2018, an extension to the right obscures the signalbox seen in the image above. (Author)

Whitwell & Reepham station and signalbox, looking north towards Melton Constable in January 1959. The former Norfolk & Suffolk Joint Railway footbridge (No. 275) was relocated from Roughton Road Junction in 1930 and replaced the original timber girder one. (R. M. Casserley, courtesy of Margaret Casserley)

Looking roughly in the same direction as the pre-closure view, the restoration work at Whitwell & Reepham station can be seen in this August 2018 view. The signalbox is a replacement for that which closed in 1966 and new buildings have been added to serve visitors. (Author)

The station building at Whitwell & Reepham was in the 'large pavilion' style and opened on 1 July 1882. Retained for goods traffic after closure to passengers, it was officially closed on 15 June 1983. The Marriott's Way runs through the station. (Author)

Lenwade station, looking Up towards Melton Constable in January 1959, was provided with another 'small pavilion' type building. The Type 1B signalbox by the level crossing probably dates from 1915 and replaced the original sited on the platform on the other side of the station building. (R. M. Casserley, courtesy of Margaret Casserley)

The station buildings at Lenwade seen from the roadside, with a dozen or more now classic cars visible, in October 1976 during an apparent enthusiasts' visit. The now extended station building survives as a private residence alongside the Marriott's Way. (R. M. Casserley, courtesy of Margaret Casserley)

Attlebridge station from an old postcard, showing the 'small pavilion' building of 1882, crossing gate cabin (in use by 1904) and concrete-post platform fencing installed c. 1916. The notice boards are variously branded 'LNER' and 'LMS'. (Casserley Collection, courtesy of Margaret Casserley)

Looking Up the line towards Melton Constable, Drayton station, with Whitwell & Reepham, was one of the two original passing places on the L&FR extension to Norwich. The Taverham Road overbridge (No. 257) can be seen beyond the footbridge (No. 256). (R. M. Casserley, courtesy of Margaret Casserley)

M&GNJR C Class 4-4-0 No. 80 (built by Beyer Peacock in 1899 and withdrawn in 1937) heads the 5.20 to Melton Constable out of Norwich City station in June 1929. To the left are the water tank and loco crew's mess hut. (H. C. Casserley, courtesy of Margaret Casserley)

Another C Class locomotive, No. 38 (built 1894 by Sharp Stewart & Co. and later fitted with an extended smokebox), stands at Norwich City with the 7.18 to Melton Constable in June 1936. The station was opened on 2 December 1882. (H. C. Casserley, courtesy of Margaret Casserley)

Looking north at Norwich City towards Norwich South signalbox in January 1959. The engine shed was a steel and corrugated iron structure built by the L&NER in 1944 to replace the original, which was destroyed during an air raid. The turntable was beyond the signalbox. (R. M. Casserley, courtesy of Margaret Casserley)

A M&GN Joint Railway Preservation Society railtour on 21 May 1960 began from Norwich City behind ex-L&NER J15 Class 0-6-0 No. 65469 (built 1912). The station closed completely in February 1969 and was then cleared for road developments, though some small remnants can be found. (G. Parry Collection/Colour-Rail.com)

The Eastern & Midlands Railway (E&MR) line from Melton Constable to North Walsham opened on 5 April 1883, the first station to the east being Corpusty & Saxthorpe. The closed station is seen in June 1971, looking west towards Melton Constable. (R. M. Casserley, courtesy of Margaret Casserley)

74

A closer view of the station building at Corpusty & Saxthorpe, seen from the north in April 2018, the vegetation around the site has grown considerably. The building has been restored and is used as a community meeting space. (Author)

The masonry overbridge at Corpusty & Saxthorpe still bears its bridge number (115), seen here in April 2018, but there is evidence of some movement in the structure. The former station yard is now a pleasant grassed area. (Author)

Aylsham North station (opened as Aylsham Town) seen from bridge No. 128 in June 1958, with ex-L&NER J17 0-6-0 No. 65581 (built by the GER in 1910) shunting on the Down line. The cast-iron water tank is to the right while the tall signalbox is beyond the footbridge. (Colour-Rail.com)

BR Ivatt 4MT Class 2-6-0 No. 43145 runs into Aylsham North with the 12.56 Yarmouth Beach to Peterborough North on 28 February 1959, the final day of passenger services, the last stopping through train to Peterborough. The smoke box is adorned with slogans in support of Norwich City football club. (E. V. Fry/Colour-Rail.com)

The station at Holt, first opened on the branch from Melton Constable in November 1884, was remodelled in 1886 for the extension of the line to Cromer. That building was destroyed by fire in March 1926 and replaced by the one shown in this undated view. (Casserley Collection, courtesy of Margaret Casserley)

The original station site at Holt was lost to road development and the North Norfolk Railway (NNR) station is a mile to the east. The station building from Stalham has been rebuilt here and is seen on a wet day in April 2018. (Author)

Following the NNR's failed attempt to dismantle the goods shed at Thursford, a replica was built at its Holt station and now forms the Marriott Museum. Seen in front is a restored M&GNJR horse-drawn dray dating from 1902 and probably built for use at Norwich City station. (Author)

A station was not provided at Weybourne until June 1901, fourteen years after the line to Cromer opened, and a year after construction started. The station building, now preserved by the North Norfolk Railway, is seen in April 2018. (Author)

78

Ex-NCB Hunslet 0-6-0ST No. 3809 (built 1954 and fitted with a Giesl ejector in 1963) enters Weybourne station in April 2000 with a train from Sheringham, seen from the footbridge. The railway's locomotives and rolling stock are maintained at Weybourne. (Author)

A view of the station at Weybourne from Sandy Hill Lane Bridge in April 2018 after the day's trains have all departed, with the sea just visible on the horizon. The footbridge came from Stowmarket (Suffolk) on the Norwich to London line. (Author)

79

Weybourne station, seen through Sandy Hill Lane Bridge (No. 302), showing the reinstated platform shelter (built 1987) and signalbox (rescued from Holt in 1967) on the Up platform. The NNR began running steam trains to Weybourne in 1975. (Author)

The stationmaster's house also survives at Weybourne, on Sandy Hill Lane just north of the station. It was completed in October 1903, using red brick and pantiles. The walls were rendered by the 1920s, as they still are. (Author)

Sheringham station, looking Down towards Cromer in August 1946. The station opened on 16 June 1887 but was subject to major rebuilding during 1896–97. The station remained open after 2 March 1959, but the Up platform buildings were later demolished. (R. M. Casserley, courtesy of Margaret Casserley)

Sheringham station buildings seen from the road in April 2018. The NNR took over the station from BR in 1966 following complete closure of the line to Melton Constable at the end of 1964. (Author)

81

This preserved Class 101 Metro-Cammell DMU, formed of units M51188 and M56352, arrived from Holt in pouring rain at Sheringham in April 2018. The unmatched blue and green units, if not the declared destination, recall services from the 1960s. (Author)

Seen from near the reinstated level crossing at Sheringham, DMU No. 156418 forms the 10.47 train to Norwich on 24 April 2018. The halt on the Cromer side of the crossing opened on 2 January 1967 and was being extended in 2019 to accommodate longer trains. (Author)

Class 156 DMU No. 156409 with a service from Sheringham for Norwich via Cromer arrives at West Runton station under bridge No. 312 (built 1886) on 18 August 2007. The original halt was opened in September 1887. (Author)

Ex-M&GNJR C Class 4-4-0 No. 06 (built as No. 6 in 1894 and reboilered in 1930) stands at Cromer Beach with the 6.17 to Melton Constable in March 1939. The station was opened on 16 June 1887 as terminus of the E&MR. (H. C. Casserley, courtesy of Margaret Casserley)

Class 156 DMU No. 156409 stands at the much-reduced Cromer station on 18 August 2007, having arrived from Sheringham with a service to Norwich. The trainshed was lost on construction of the adjacent supermarket but the attractive station building (not shown here) has survived. (Author)

All trains to Sheringham have had to reverse at Cromer since the west curve of Cromer triangle was closed in September 1960. Cromer signalbox closed in June 2000 following resignalling of the line from Norwich, shortly after this photograph from 27 April 2000. (Author)

The M&GNJR extension west from Bourne met the MR at Little Bytham Junction and opened for goods in June 1893 and passengers the following May. Castle Bytham was one of three stations between the junction and the main line at Saxby, seen here in May 1956. (R. M. Casserley, courtesy of Margaret Casserley)

BR Fairburn 4MT Class 2-6-4T No. 42184 pilots ex-LMS 4F Class 0-6-0 No. 44419 near Saxby with a Derby to Gorleston and Cromer service in July 1958. Opening of the line through to Saxby in 1894 provided a more direct line to the MR. (H. N. James/Casserley collection, courtesy of Margaret Casserley)

The Norfolk & Suffolk Joint Railway (N&SJR) ran north from North Walsham to Paston & Knapston station, which opened on 1 July 1898. The building was designed by Cornish & Gaymer in the 'domestic revival' style. This post-closure view is form June 1971. (R. M. Casserley, courtesy of Margaret Casserley)

Mundesley-on-Sea was opened first, on 1 July 1898, as terminus of the much-delayed N&SJR line from North Walsham. Approval had already been given for the line to continue to Cromer so the extensive facilities, seen here in May 1964, were planned for through traffic. (Colour-Rail.com)

The impressive station building at Mundesley-on-Sea, designed to serve a significant passenger traffic that failed to be achieved. The exterior is seen on 3 October 1964 at the end of passenger services. It was demolished soon after complete closure in May 1965, despite protests at the time. (Colour-Rail.com)

The Down platform of Trimmingham station's island platform, taken from an old postcard. The platform was reached by steps from the overbridge at the south end of the station. The station opened on 3 August 1906 but closed on 7 April 1953 with the line from Mundesley. (Author's collection)

87

The station buildings at Overstrand were identical to those at Trimmingham but the island platform here was reached by a glazed subway, prominent in this 1914 view. Also, unlike Trimmingham, the station building here has survived as a private dwelling. (Casserley Collection, courtesy of Margaret Casserley)

Cromer Links halt was opened on the N&SJR line on 9 July 1923 to serve the nearby golf course, its construction having been delayed by the First World War. Seen here in 1947, the young men do not appear to be equipped for playing golf. (D. Thompson/Casserley Collection, courtesy of Margaret Casserley)

Breydon bridge (No. 172) was opened in 1903 to provide a link across the river at Yarmouth and connect to the N&SJR at Gorleston Junction. It is seen in this view from an old postcard with the swing span opened for vessels. The viaduct was closed in 1953 and demolished in 1962. (Author's collection)

Nothing now remains of the N&SJR station opened at Gorleston-on-Sea on 13 July 1903 and closed on 2 May 1970. The buildings were demolished in 1976 but the former Station Hotel on Lowestoft Road survives to mark the location, as seen in April 2018. (Author)

Ex-L&NER D16/3 Class 4-4-0 No. 62613 (built by the GER in 1923, withdrawn 1960) passing Gorleston Super Holiday Camp in July 1957. The Gorleston-on-Sea holiday camp was open from 1937 to 1973. The locomotive was at that time allocated to Yarmouth Beach. (Colour-Rail.com)

Another L&NER-type engine, L1 Class 2-6-4T No. 67704 (built 1948, withdrawn 1960), stands at the Down platform of Hopton station in June 1957 with a train for Yarmouth Beach, thought to be a Saturday express from London via Lowestoft. (E. Alger/Colour-Rail.com)

The N&SJR station at Hopton was opened on 13 July 1903 and remained so until 2 May 1970. Nothing remains of the station, now lost under a housing development, but the former stationmaster's house, seen here in April 2018, and two railway cottages remain on Station Road. (Author)

Seen again with another summer Saturday through train from Liverpool Street to Gorleston, L1 Class No. 67704 arrives at Corton station Down platform in June 1957. This station also opened in July 1903 and survived until May 1970. (Colour-Rail.com)

91

The only remaining N&SJR station building is from the Up side at Corton, which has survived in residential use (grid ref. TM 54097), seen here from the east in April 2018. The nearby stationmaster's house and cottages are also in use as private dwellings. (Author)

Former N&SJR under bridge No. 2427, north of Gunton (grid ref. TM 543963), is on the southern boundary of Pleasurewood Hills family theme park. Seen here from the east in April 2018, it also marks the northern extreme of an accessible section of the trackbed. (Author)

Nothing now remains of Lowestoft North station, the site now covered with a housing development, but the former stationmaster's house still stands on Station Road, near the site of over bridge No. 2424, seen in April 2018. (Author)

N&SJR over bridge No. 2420, at Normanston Drive (grid ref. TM 538937), is one of several plate girder bridges marking the route of the Great Eastern Linear Park that follows the N&SJR trackbed north from Lowestoft. It is seen here looking south. (Author)

Lowestoft station was opened by the Norfolk Railway on 1 July 1847 and first used by M&GNJR trains via the N&SJR from July 1903. The line north to Gorleston closed in May 1970. This undated image shows the overall roof and platform canopies that were removed in 1992. (Colour-Rail.com)

Lowestoft Central remains open as the easternmost station on the UK national rail network and is seen here in January 2005; it has been plain 'Lowestoft' since 1971. The station was refurbished in 2013 and in 2019 was due to have further investment. (Author)

94

Acknowledgements & Sources

I am very grateful to Laura Dickinson, John Hobden (M&GN Circle), and David King and Dennis Greeno (both Midland & Great Northern Joint Railway Society) for reading draft text at various stages and kindly commenting, at short notice, on content and style. Dennis and David also welcomed me at the North Norfolk Railway and provided much helpful background material. Malcolm Banyer and Richard Walker (both M&GN Circle), Jonathan Edwards, Jamie Everitt (Norfolk County Council) and David Viner provided further information and pointed out other sources.

My daughter, Amber-Ruth Watson, kindly accompanied me on some field trips and I am delighted to include some of her images in the book. I am also grateful for the courtesy of the occupiers of the various properties visited during research for the book.

I make no apologies for making extensive use of the excellent photographs by Henry (H. C.) Casserley and Richard (R. M.) Casserley and am very grateful to Margaret Casserley for making copies available whilst the collection was still in the family's care. Margaret and her daughter Mary deserve special thanks for their efforts to identify relevant images from the collection.

The following also kindly provided access to images of their own or from the collections they manage, many of which there has sadly not been space for: Mike Beale, Gail Clingo (Bourne United Charities), Claire Everitt (Norfolk County Council), Rex Needles, and Adrian C. Whittaker (M&GN Circle). Paul Chancellor of Colour Rail provided his usual prompt and efficient service.

Jon Dixon (Anglezarke Dixon Associates) produced the wonderful map, so very necessary with this rather complicated network.

Thanks as ever to everyone at Amberley Publishing for their help and patience, especially to Connor Stait for his continuing support and encouragement.

I have not consulted primary sources for this book, relying on the wealth of published material and can recommend in particular the publications listed below, especially Nigel Digby's two-volume opus and Bob Essery's locomotive history:

Digby, Nigel J. L., *The Stations and Structures of the Midland & Great Northern Joint Railway, Vol. 1: Lowestoft to Melton Constable* (Lydney: Lightmoor Publishing, 2014).
Digby, Nigel J. L., *The Stations and Structures of the Midland & Great Northern Joint Railway, Vol. 2: Norwich to Peterborough and Little Bytham* (Lydney: Lightmoor Publishing, 2015).
Essery, Bob, *The Midland & Great Northern Joint Railway and its Locomotives* (Lydney: Lightmoor Publishing, 2009).

Also useful, though older, are:

Clark, Ronald H., *A Short History of the Midland & Great Northern Joint Railway* (Norwich: Goose & Son, 1967).
Rhodes, John, *The Midland & Great Northern Joint Railway* (Shepperton: Ian Allan, 1979).
Wrottesley, A. J., *The Midland & Great Northern Joint Railway* (Newton Abbott: David & Charles, 1981).

There is of course much information available via the M&GN Circle and its excellent Bulletin that provides so much more detail than could possibly be included here. The websites of both the Circle and the Joint Railway Society are well worth visiting too. I have tried to ensure that information in the book is correct, and not repeat past errors where I am aware of them, but of course take full responsibility for the end result and any remaining errors or omissions.

Every attempt has been made to seek permission for copyright material used in this book. However, if we have inadvertently used copyright material without permission or acknowledgement we apologise and we will make the necessary correction at the first opportunity.